David Okum

IMPACT

CINCINNATI, OHIO
www.impact-books.com

About the Author

David Okum has worked as a freelance artist and illustrator since 1984 and has had his comic book work published since 1992, starting with a story published in a *Ninja High School* anthology by Antarctic Press. He has since been included in two other Antarctic Press anthologies and several small-press comic books. His writing and artwork have appeared in six role-playing books published by Guardians of Order. He is also the author and illustrator of *Manga Madness* (IMPACT Books, 2004). David studied fine art and history at the University of Waterloo in Ontario, Canada, and is a high school art teacher. He currently possesses no known superpowers.

Dedication

To the crazy people who invade my house once a week to play games and keep my family awake: Nick Rintche, Mitch Krajewski, Stephen Markan, Rich Kinchlea and Dave Kinchlea. Also, to Arek Skibicki, Vlad Kinastowski and Peter Cornish: Thank you for the inspiration for thousands of heroic adventures.

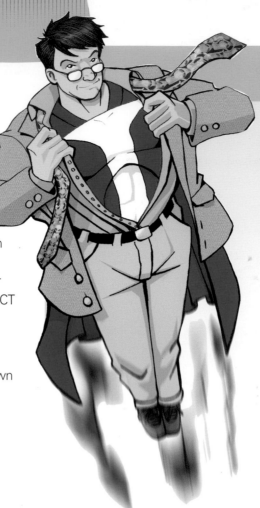

Acknowledgments

I'd like to thank the following people for their help and contributions as I put this book together:

My editors, Pam Wissman and Stefanie Laufersweiler, designer Wendy Dunning, production artist Matthew DeRhodes and production coordinator Mark Griffin, for making my work look good.

Renshi Ken Verbakel and Shihan Dai Tammy Milne from Bonsai Martial Arts, who provide excellent instruction in karate and answer my many questions.

Harry Kremer, who introduced me to the world of comics. We miss you, Harry.

Jennifer, Stephanie and Caitlin Okum, for their individual inspiration and infinite patience as this book just kept getting bigger and bigger. Thank you.

09 08 07 06 05 5 4 3 2 1

Library of Congress Cataloging in Publication Data

Okum, David.
 Superhero madness / David Okum.— 1st ed.
 p. cm
 Includes index.
 ISBN 1-58180-559-4 (pbk. : alk. paper)
 1. Cartooning—Technique. 2. Comic books, strips, etc.—Technique. 3. Heroes—caricatures and cartoons.
I. Title.

NC1764.O38 2004
741.5—dc22 2004052309

Editor: Stefanie Laufersweiler **Designer:** Wendy Dunning
Production artist: Matthew De Rhodes **Production coordinator:** Mark Griffin

Metric Conversion Chart

To convert	to	multiply by
Inches	Centimeters	2.54
Centimeters	Inches	0.4
Feet	Centimeters	30.5
Centimeters	Feet	0.03
Yards	Meters	0.9
Meters	Yards	1.1
Sq. Inches	Sq. Centimeters	6.45
Sq. Centimeters	Sq. Inches	0.16
Sq. Feet	Sq. Meters	0.09
Sq. Meters	Sq. Feet	10.8
Sq. Yards	Sq. Meters	0.8
Sq. Meters	Sq. Yards	1.2
Pounds	Kilograms	0.45
Kilograms	Pounds	2.2
Ounces	Grams	28.3
Grams	Ounces	0.035

table of Contents

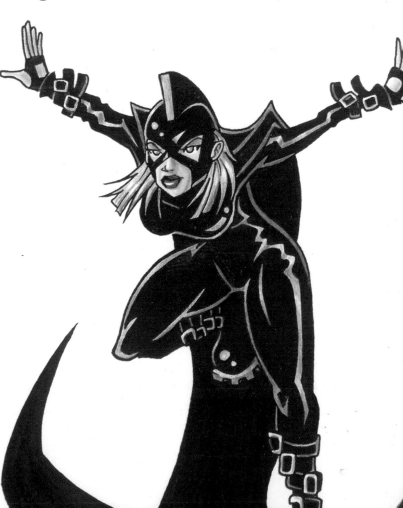

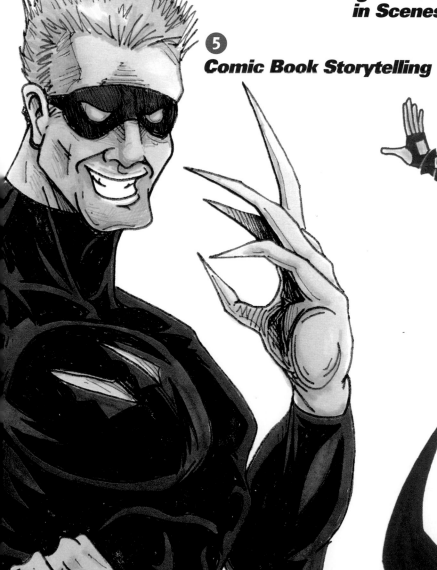

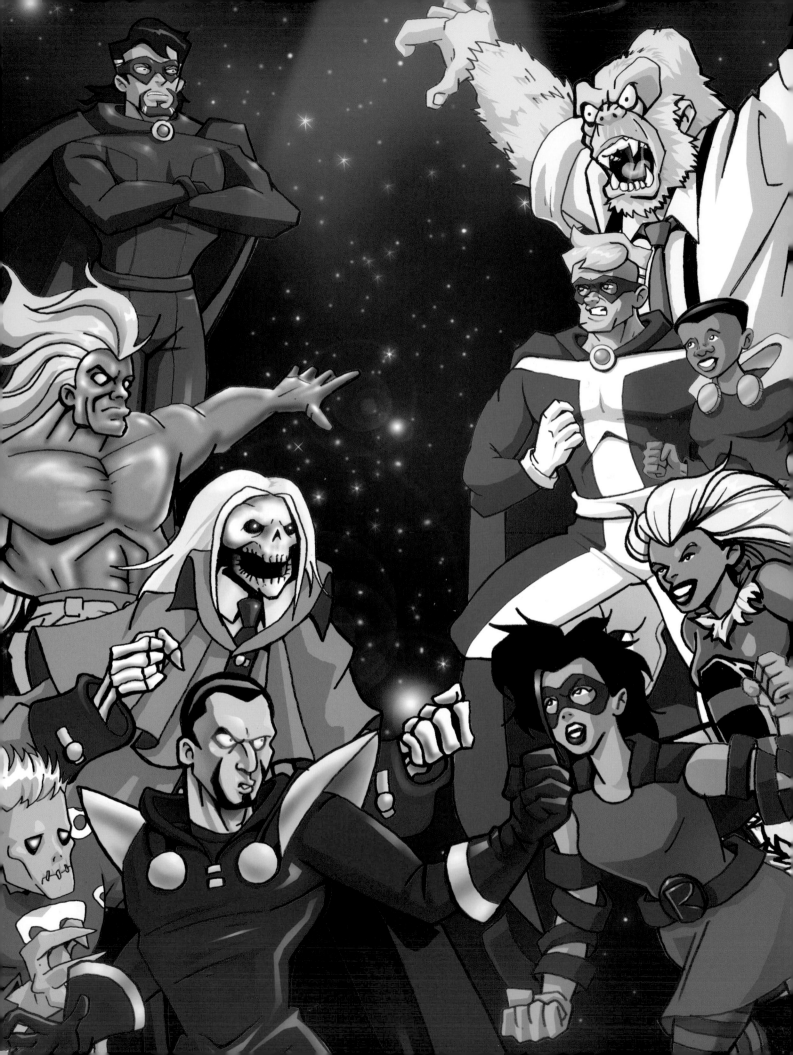

Introduction

I drew my first comic when I was eight. "Mr. Mouse and Jim" was an adventure comic of a globe-trotting mouse and his plucky rat sidekick. Later, I expanded into science fiction comics with "Galactic Wars." It wasn't until high school that I thought to try my hand at a superhero comic.

I remember thinking as I drew the pages for my freshman art class, "Why haven't I done this before?" I enjoyed superhero stories because they allowed me to draw whatever I wanted. I could have knights, tanks, robots and aliens all in the same story, on the same page, in the same panel. The creative possibilities seemed limitless. I created a cast of heroes and villains and, with the help of my friends, crafted fantastic stories of heroism and adventure that we still talk about to this day.

When I started thinking about this book, I dug out my old drawings and found hundreds of pages of character and story ideas. It was like bumping into old friends that I had not seen for twenty years. It's nice to have them back.

Superheroes hold a special place in our hearts. They actually exceed the potential of humanity. They are more than human, but they all have problems and weaknesses the reader can identify with. They are the ultimate power fantasy. Who hasn't dreamed they could fly or draw upon super strength or skills when needed?

Getting into the comics business is tricky at best. It's all about building skills, making contacts and maturing as an artist. This book may help you on that road, but there are many side paths that can be taken. You will learn valuable skills in anatomy, proportion, drawing techniques and layout, and gain some insights into the medium of comics. So if you want to learn how to draw superhero comics or if you just want to draw your favorite hero in a cool pose, this book is for you.

Get ready for Superhero Madness!

BEFORE YOU BEGIN...

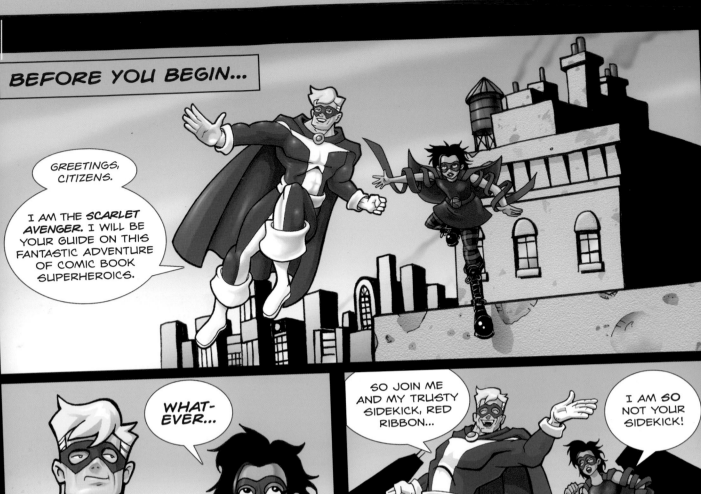

GREETINGS, CITIZENS.

I AM THE **SCARLET AVENGER**. I WILL BE YOUR GUIDE ON THIS FANTASTIC ADVENTURE OF COMIC BOOK SUPERHEROICS.

WHAT-EVER...

SO JOIN ME AND MY TRUSTY SIDEKICK, RED RIBBON...

I AM SO NOT YOUR SIDEKICK!

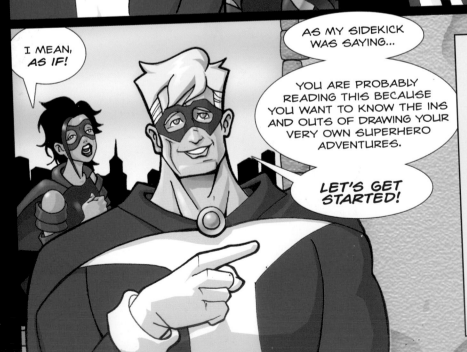

I MEAN, AS IF!

AS MY SIDEKICK WAS SAYING...

YOU ARE PROBABLY READING THIS BECAUSE YOU WANT TO KNOW THE INS AND OUTS OF DRAWING YOUR VERY OWN SUPERHERO ADVENTURES.

LET'S GET STARTED!

WHAT YOU SHOULD KNOW...

1. DRAW LOOSELY AND LIGHTLY AT FIRST. YOU CAN CLEAN UP YOUR PENCIL MARKS EASIER IF YOU DON'T PRESS SO HARD.

2. TRY TO THINK OF YOUR DRAW-INGS AS 3-D FORMS. USE PER-SPECTIVE AND FORESHORTENING TO MAKE YOUR DRAWINGS COME TO LIFE!

3. PUSH YOURSELF TO PRACTICE, PRACTICE, PRACTICE.

DRAW THE HUMAN FIGURE EVERY CHANCE YOU GET.

DRAW ALL THE TIME.

DRAW EVERYTHING.

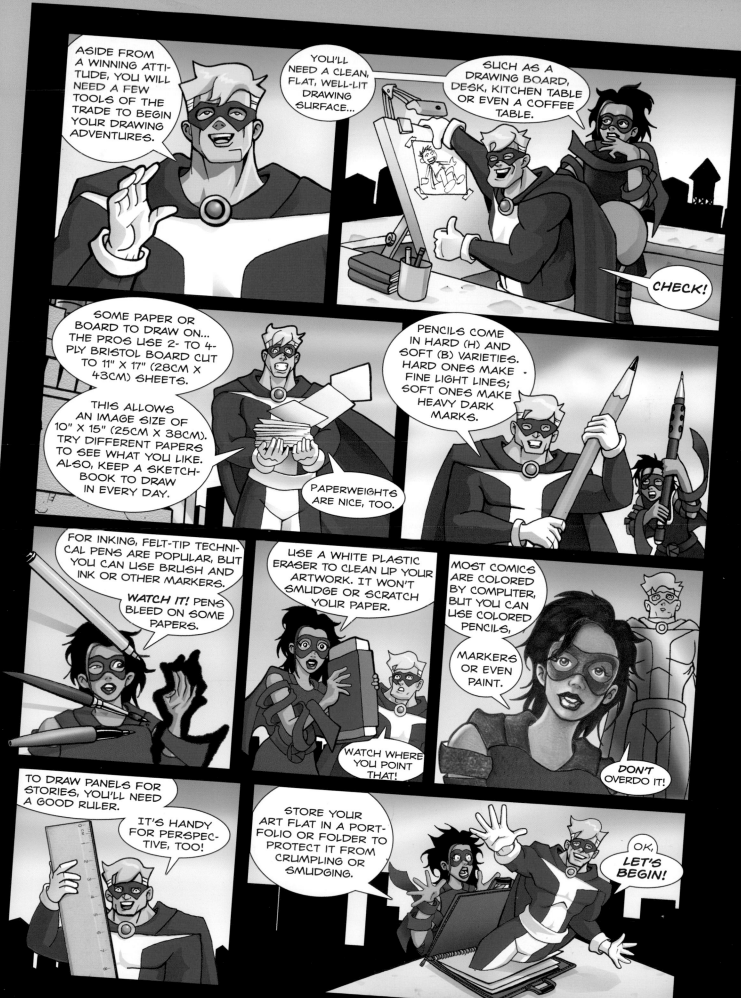

THE HISTORY OF THE SUPERHERO...

SUPERHERO COMICS ARE A RATHER RECENT INVENTION. EARLY COMICS WERE SIMPLY REPRINTS OF POPULAR NEWSPAPER STRIPS. THE TRADITION OF THE SUPERHERO EVOLVED FROM "PULP" HEROES SUCH AS DOC SAVAGE AND THE SHADOW. THESE EARLY MYSTERIES AND ACTION ADVENTURES PAVED THE WAY FOR THE MASKED CRIME-BUSTER WE RECOGNIZE TODAY AS THE SUPERHERO.

SUPERMAN APPEARED IN 1938 AND BATMAN FOLLOWED A YEAR LATER. THE EARLY SUPERHEROES OF THE GOLDEN AGE OF COMICS WERE AN IMPORTANT PART OF THE WORLD WAR II EFFORT. CAPTAIN AMERICA AND WONDER WOMAN HAD PATRIOTIC COSTUMES AND ORIGINS.

SILVER AGE HEROES WERE MOSTLY UPDATED CHARACTERS FROM THE 1940S. A NEW CROP OF YOUNGER, HIPPER HEROES EMERGED IN THE EARLY 1960S, WITH DOUBTS AND PROBLEMS THAT READERS COULD RELATE TO.

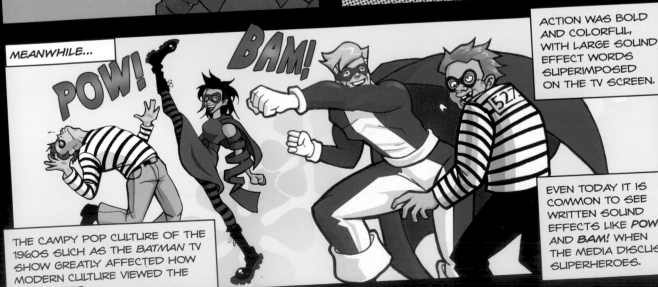

MEANWHILE...

POW!

BAM!

ACTION WAS BOLD AND COLORFUL, WITH LARGE SOUND EFFECT WORDS SUPERIMPOSED ON THE TV SCREEN.

THE CAMPY POP CULTURE OF THE 1960S SUCH AS THE BATMAN TV SHOW GREATLY AFFECTED HOW MODERN CULTURE VIEWED THE SUPERHERO.

EVEN TODAY IT IS COMMON TO SEE WRITTEN SOUND EFFECTS LIKE POW! AND BAM! WHEN THE MEDIA DISCUSS SUPERHEROES.

THE 1970S SAW A WANE IN INTEREST IN SUPERHERO COMICS AND A RISE OF HORROR, FANTASY AND MARTIAL ARTS COMICS. SUPERHEROES REMAINED POPULAR IN OTHER MEDIA SUCH AS TV AND MOVIES.

SUPERHERO COMICS TRIED TO BECOME MORE RELEVANT AND CHANGE WITH THE TIMES, BUT THEY LOST SOME OF THEIR FUN AND INNOCENCE IN THE PROCESS. SERIOUS SOCIAL ISSUES SUCH AS DRUG ABUSE AND HOMELESSNESS WERE ADDRESSED IN A MORE SENSITIVE, MATURE WAY.

THE 1980S SAW COMICS RESTRUCTURE THEIR HISTORIES AND DEVELOP A GRITTIER FEEL, BECOMING DARK, VIOLENT AND SELF-AWARE.

THE SUPERHERO WAS REBORN IN THE 1990S. ARTISTS AND WRITERS, FRUSTRATED BY THE LOSS OF THEIR WORK TO HUGE COMPANIES, BEGAN TO SELF-PUBLISH. THE RESULT WAS A RENAISSANCE OF NEW IDEAS. SOME OF IT WAS BRILLIANT AND SOME OF IT WAS HORRIBLE, BUT ALL OF IT CREATED OPPORTUNITIES FOR A NEW GENERATION TO DISCOVER SUPERHEROES.

TODAY, MORE PEOPLE ARE FINDING OUT ABOUT SUPERHEROES FROM OTHER SOURCES LIKE FILMS, CARTOONS AND VIDEO GAMES. THE INTERNET ALLOWS CREATORS TO PUBLISH THEIR OWN COMICS ONLINE.

THE CONCEPT OF THE SUPERHERO WAS ANALYZED, CHALLENGED AND RECONSTRUCTED TO CREATE SOMETHING NEW, EXCITING AND DANGEROUS.

TWO BIG INFLUENCES ON COMICS TODAY ARE MANGA AND REALISTIC PAINTINGS OF SUPERHEROES. BOTH TRENDS LET US SEE THE SUPERHERO WITH FRESH EYES.

superhero
Costumes

Aside from a fantastic origin story and unique superpowers, superheroes need a distinctive costume to help establish their heroic identity. The standard superhero costume used to be a skintight body stocking or tights, but today costumes come in many forms.

Costumes usually have identifying colors or symbols that reveal the origins of the hero (such as a flag), reinforce the concept or theme behind the hero (such as an animal or letter) and add a visual flair or attitude to the hero (such as a skull). They also can conceal the hero's true identity.

Realistically, capes are very impractical for active people like superheroes. They would constantly get in the way, but in comics they look very cool. Capes can be useful—they can be bulletproof or let the hero glide short distances. They can also add to the drama and presence of a hero, making him look bigger or more mysterious. They can add movement and expression to an otherwise static figure, or reinforce the hero's action.

Masks help disguise the hero's secret identity no matter how small they may be. Depending on how realistic you want your heroes to be, you can create a secret identity by simply adding glasses and changing the hairstyle. No one ever seems to catch on.

When heroes must change from their secret identity to their heroic identity, some utter a word, spin around, press a button on a watch or get struck by lightning to magically transform. Others put on their costumes like regular clothes, or wear their costumes underneath their everyday clothing. Those without an identity to protect can dress any way they like at any time.

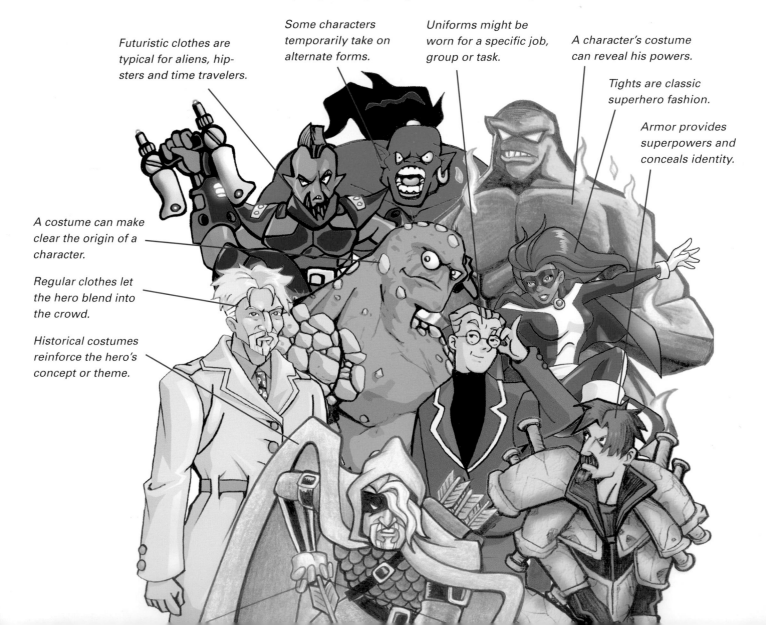

Futuristic clothes are typical for aliens, hipsters and time travelers.

Some characters temporarily take on alternate forms.

Uniforms might be worn for a specific job, group or task.

A character's costume can reveal his powers.

Tights are classic superhero fashion.

Armor provides superpowers and conceals identity.

A costume can make clear the origin of a character.

Regular clothes let the hero blend into the crowd.

Historical costumes reinforce the hero's concept or theme.

ten tips for
Superhero Style

1 **Superheroes should stand out from the crowd.** Use heroic proportions for classic heroes. Heroes should have a nobility and presence that rises above mere mortals. This being said, giving superhuman characters human weaknesses such as illness, emotional problems or physical defects lets readers relate better to the character.

2 **Use reference photos, preferably ones you have taken yourself.** Setting up your own photos will give you ultimate control over lighting, angle and composition. Never be a slave to your photos; improve upon them. Photos can flatten and distort an image. Use your knowledge of the figure and dynamic storytelling to make the anatomy clearer and add intensity to the poses.

3 **Draw the reader into the panel by showing a foreground, a middle ground and a background.** Use lines and movement to move the viewer's eye into your artwork, not away from it. Don't put the point of interest in the exact center of the panel.

4 **Use dynamic diagonals in your compositions.** This helps avoid tangents (when the edges of objects you draw touch but do not overlap) with the edge of the panel or page. Off-kilter angles also create tension and movement.

5 **Use dynamic angles and unusual points of view.** Try to show the action from below or above from time to time. This variety of the images keeps the viewer interested.

6 **Use body language and expression to reveal emotion and create dramatic intensity.** Show the sweat and exertion required to save the world. This makes the superhuman feats seem more immediate and human, allowing readers to better relate to the action.

7 **Show movement at the most extreme moment of the action.** The figure should be leaning into the farthest reach of the punch or at the point of impact in a fall. Choose the most exciting point of the movement.

8 **Relate the world to the action you are drawing.** Make hair and capes blow in the wind; have the hero squint and cover his eyes from the sun as he scans the horizon.

9 **Make the world react to the action you are drawing.** If a hero punches the wall, make nearby windows shatter and send plaster dust flying in the shock wave.

10 **Keep it simple.** Too many lines can get confusing. Don't draw every brick on the wall or every strand of hair on the hero's head. More detail doesn't always improve a drawing.

enter the Superheroes

Superheroes come in many shapes and sizes. Some are more powerful and established; others are weaker and less experienced. Heroes usually have a special villain or group of villains tied to their origins that make their lives difficult. These connections create motivation and drama in the story and make the challenges personal.

Superheroes are usually reluctant heroes. They often lead a double life: One is normal and peaceful while the other is flashy and dangerous. Although comics readers would love to have powers like their favorite heroes, the reality is that the responsibility that comes with that power is so great that no challenge, no matter how difficult or inconvenient, can be ignored.

Superheroes-team-up-to-defuse-a-cosmic-crisis is a classic comic storyline. More often than not, the heroes take a few swings at each other before realizing they are on the same side.

The superheroes depicted on these pages are just a sample of what is possible. Heroes can be a combination of two or more types. Here are some of the more common types of heroes.

 The Speedster has powers of super speed. No one can hope to run away from this hero.

 The Energy Blaster fires bolts of energy from a special weapon, his hands or his eyes.

 The Mythic Hero is the embodiment of classic myths and legends like Robin Hood or Hercules.

 The Powered Armor Hero wears a high-tech suit of armor that gives him the powers needed to be a superhero.

 The Detective Hero swoops out of the night to solve crimes.

 The Gadget Hero uses super technology to solve crimes and perform heroic deeds.

The Magic Master taps into the secret forces of the universe, casting spells and maintaining the cosmic balance.

 The Acrobat leaps into adventures with style and wit.

 The Martial Artist uses hand-to-hand combat skills with wisdom and precision.

The Flying Hero is a popular addition to any superhero team, allowing for quick transportation and information gathering.

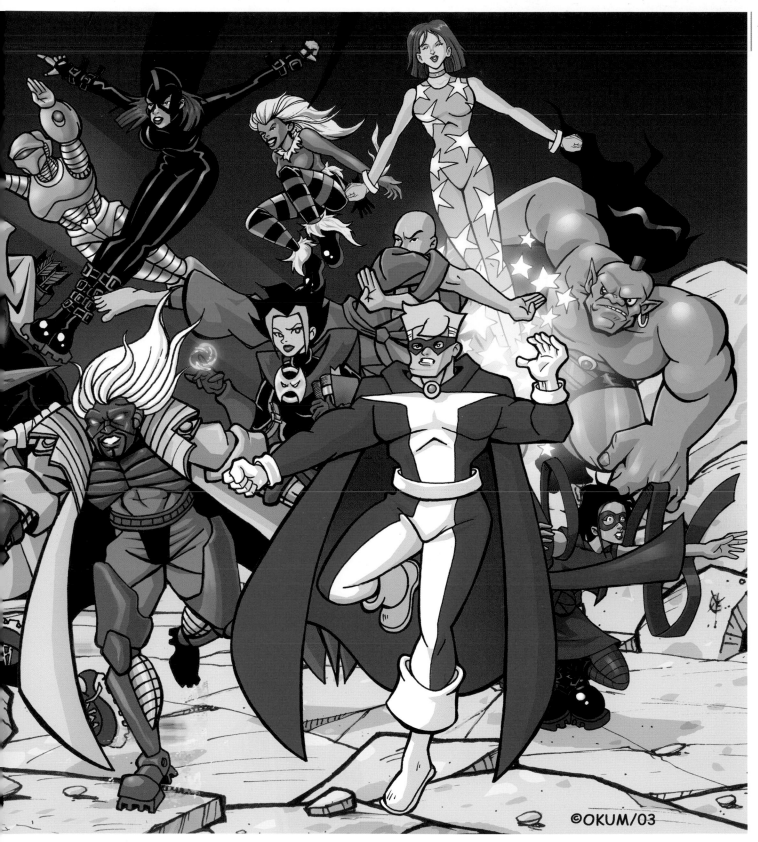

©OKUM/03

The Ultimate Hero is often the toughest hero on Earth and is usually the focus of the story.

The Big Tough Guy is a powerful force of nature but usually has a soft, sentimental side.

The Teen Hero is the brash hero-in-training. She's allowed to make mistakes but often has to grow up quickly in the never-ending battle against evil.

attack of the **Villains**

These are the guys you love to hate. Villains often steal the show from the heroes with dubious plots to take over Earth or destroy the universe. They all have their own motivations and don't think that what they are doing is evil. Villains have their own twisted logic to justify the extremes of their behavior. The combination of superpowers and evil genius is a dangerous blend.

Here are some of the more common kinds of villains.

The Robot is the perfect symbol of technology gone wrong. What was meant to help humanity has decided that humanity is inferior and must be destroyed.

The Arch Villain is the ultimate threat. Hatching one devilish scheme after another, he always has an escape plan ready just in case.

The Alien is a fearsome foe from another planet or dimension who wants to conquer or destroy Earth.

The Giant Monster stomps around the city causing havoc and destruction. This is a challenge for even the most powerful super-hero team.

The Monster is the embodiment of humanity's greatest fears: demons, vampires and things that go bump in the night.

The Thug is necessary to distract the heroes from the master plan of the bad guys and create wave after wave of obstacles to overcome.

The Tough Villain is not always very intelligent but is an intimidating opponent. This villain is often tougher, but not smarter, than the Arch Villain.

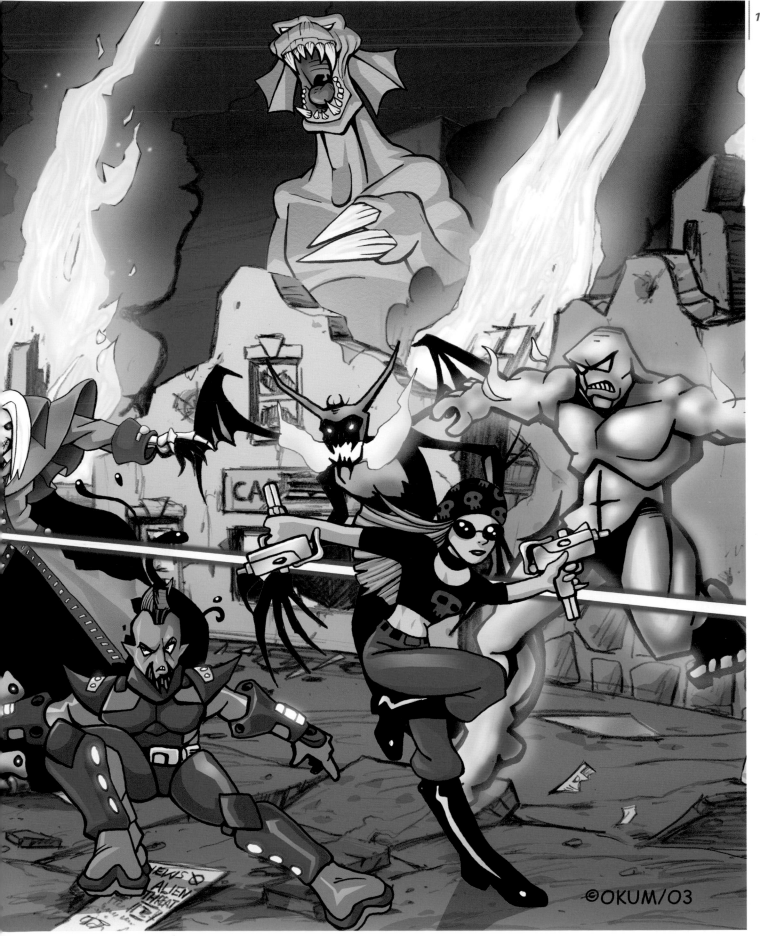

the basics of
Construction

The key to drawing realistically is in observation. If you look closely at the world around you, you'll notice that objects are made up of basic shapes: circles, squares, rectangles and triangles. If you take into account that the objects are really three-dimensional and not flat, you are actually seeing collections of spheres, cubes, cylinders and cones. By combining these basic 3-D forms, you can create an infinite number of new objects.

Every Drawing Begins With Basic Shapes

Don't be intimidated by the complexity of figures or high technology when you set out to draw. You can probably handle drawing spheres, cones, cylinders and cubes. Try drawing these basic forms first. Keep them loose. It only takes a few minutes to fill a page with 3-D forms.

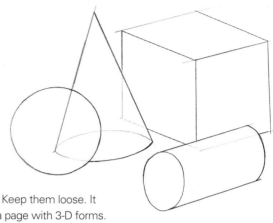

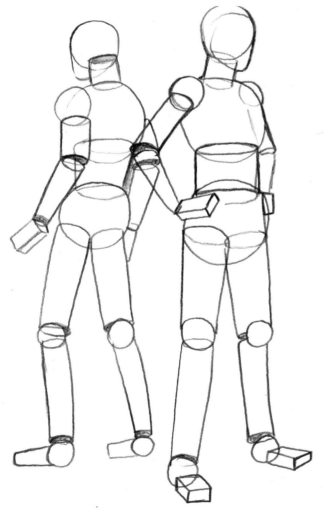

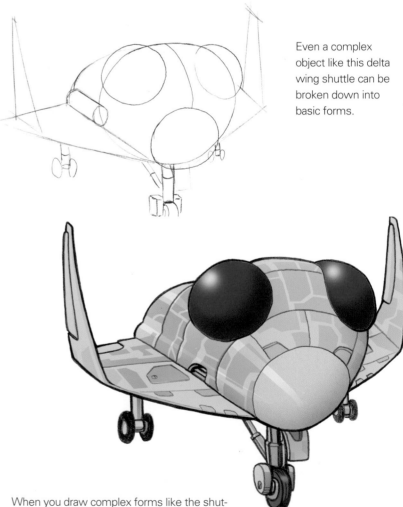

Even a complex object like this delta wing shuttle can be broken down into basic forms.

When you break it down to the basics, the human figure is really just a collection of cylinders and spheres.

When you draw complex forms like the shuttle, begin with the basics. Gradually build upon these shapes, adding details as you go. Your art will look more realistic if you follow the basic structure as the foundation of your drawings.

shading and
3-D Effects

To make drawn forms appear realistic, you need to consider the way light falls on them and how they cast shadows. Your shading should have four to six levels (or values) of gray, from lightest to darkest.

The first thing you need to establish is where your light source is located before you begin shading your drawing. To make the drawing more 3-D, follow the form of the object you're shading as you drag the pencil or paintbrush across the paper. Imagine you are wrapping the forms in string and each pencil or brushstroke is a strand. Your pencil lines should literally wrap around the form.

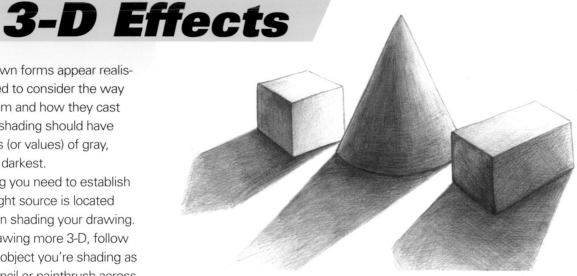

Shade a Few Simple Forms

Know where your light source is before you start shading. Keep the direction of that light the same for all objects in your drawing. The change from light to dark is gradual on round objects and more abrupt on angular ones. When you master shading simple forms, combine them for something more complex. Keep in mind how each form relates to another. The forms will cast shadows and highlights onto each other.

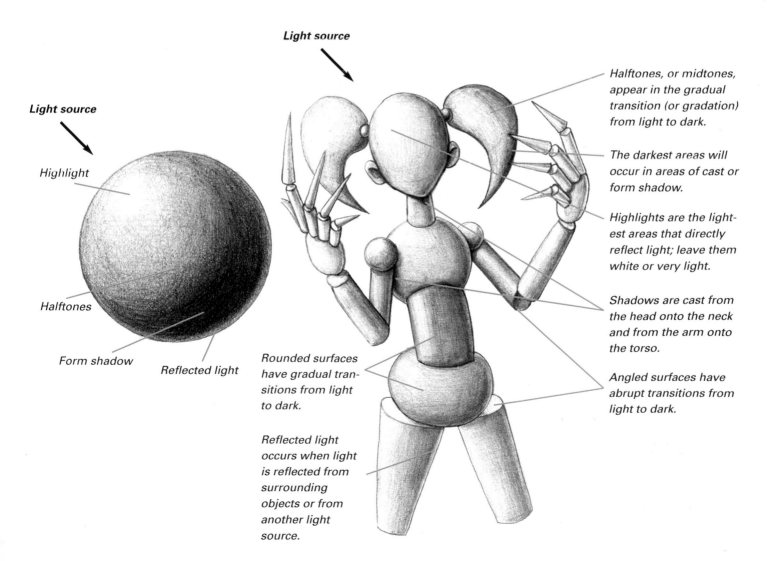

Light source

Halftones, or midtones, appear in the gradual transition (or gradation) from light to dark.

The darkest areas will occur in areas of cast or form shadow.

Highlights are the lightest areas that directly reflect light; leave them white or very light.

Shadows are cast from the head onto the neck and from the arm onto the torso.

Angled surfaces have abrupt transitions from light to dark.

Light source

Highlight

Halftones

Form shadow Reflected light

Rounded surfaces have gradual transitions from light to dark.

Reflected light occurs when light is reflected from surrounding objects or from another light source.

dramatic
Light and Shadow

*L*ike most things in a superheroic world, light and shadow should be exaggerated and used for dramatic effect. Painters, photographers and film-makers have been experimenting with dramatic light and shadow for centuries. Try some of these techniques to add drama to your drawings.

Using high-contrast shading can create a very dark and moody image. One problem with this technique is that the image can appear very flat.

Use unusual lighting angles to add tension and novelty to your drawings. The figure looks very different when it is illuminated from the top, bottom or side.

pencilling Techniques

Professional comics are produced in stages by several creators: the writer, the penciller, the inker, the letterer and the colorist. Few professional pencillers ink and color their own work. Production deadlines are just too tight to do it all. Consequently, most professional pencillers must create very tight images that appear very much as they will appear in the finished product. This makes the inker's job easier and avoids possible delays and continuity errors.

You will probably be inking and coloring your own artwork, so your pencils can be looser since you will be able to clean them up with ink later. Pencils come in a wide variety of hard (or light) graphite (H) and soft (or dark) graphite (B). The higher the number before the letter, the harder (8H) or softer (8B) the pencil. HB pencils provide a tonal balance between hard and soft graphite.

Pencilling art is often done in three stages: (1) loose gesture and construction drawing, (2) tighter drawing, and (3) detailed rendering.

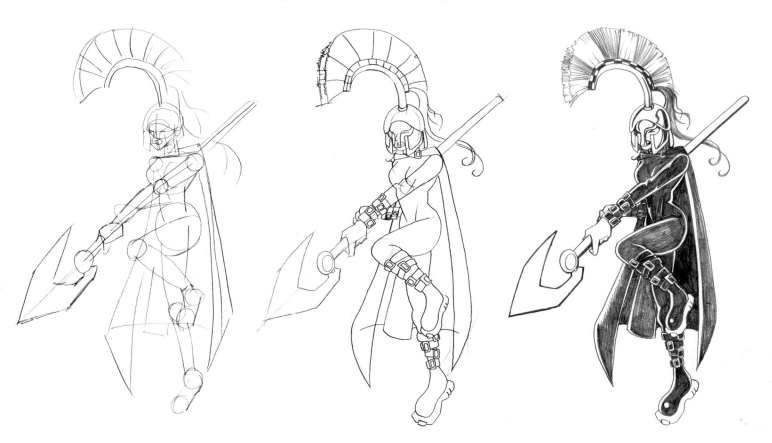

1 Most artists choose a 2B or HB pencil for this sketchy, exploratory stage because softer graphite is difficult to erase cleanly since it smudges easily. Don't press too hard—the harder pencils may create indentations in the paper that could make inking and coloring difficult.

2 Using a softer lead (such as an H or HB), clean up the artwork and tighten the pencil lines. Erase confusing lines and simplify existing lines. Your own style will dictate how you use line in your drawings, but if you keep the number of lines to a minimum, you will produce a much clearer image.

3 The rendering stage adds a 3-D quality to the finished drawing. Carefully vary the thickness of the lines to help define form, value and weight. Indicate areas of shadow and highlights. Instead of filling in areas of solid black with pencil, you may mark these areas with a small "X" to be inked later. This saves quite a bit of time and avoids possible smudging problems.

inking Basics

More than just "tracing" a pencilled image, inking allows the artwork to be developed further. Ink lines are also easier to reproduce, and they will not smudge or fade like pencil. Inked lines are darker and more consistent than pencilled line.

Everyone has individual tastes when it comes to inking. Some people love thin, uniform lines that economically describe the form. Others prefer thicker, more expressive lines. Avoid lines that are too similar in thickness. Try to change the pen size from time to time. Objects that are closer to the viewer or in shadow should have a thicker line.

Ink other people's work to develop your inking skills. Every artist will have a different pencilling style to interpret.

Inking Gear

There are many kinds of reusable and disposable technical pens. Collect a variety of sizes from .005 (thin) to .08 (thick). Use ink that is permanent and waterproof.

Felt-tip brush pens are also available, but they take some getting used to. Ink and crow quill pens have been the most widely used inking tools in comics. They can be somewhat difficult to master but provide more flexibility than technical pens. Brush and ink can create very expressive lines but can be tricky to use competently without lots of practice.

Have some correction fluid or white paint on hand to cover any mistakes.

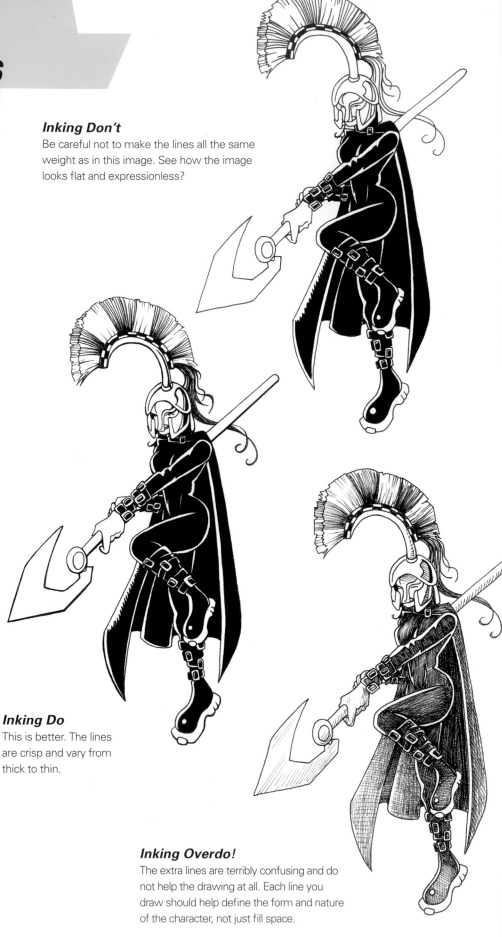

Inking Don't
Be careful not to make the lines all the same weight as in this image. See how the image looks flat and expressionless?

Inking Do
This is better. The lines are crisp and vary from thick to thin.

Inking Overdo!
The extra lines are terribly confusing and do not help the drawing at all. Each line you draw should help define the form and nature of the character, not just fill space.

super Color!

Color brings a superhero drawing to life. Every character will demand different treatment to suit their individual concept. A villain would be colored differently than a teenage supermutant.

The colors of the spectrum can be organized as a wheel from which you can choose a variety of color schemes. Black and white are not colors but are considered shades (black darkens a color) and tints (white lightens a color).

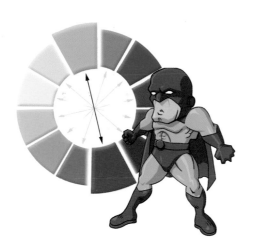

Complementary Colors

Two colors opposite each other on the wheel are called complementary. When placed side by side, they instantly attract attention. Examples are red and green, blue and orange, and yellow and violet.

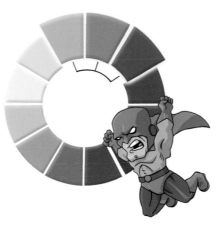

Analogous Colors

Analogous colors appear side by side on the wheel. They create a nice harmony because they are so closely related to each other. Examples are blue, blue-green and green or yellow, yellow-orange and orange.

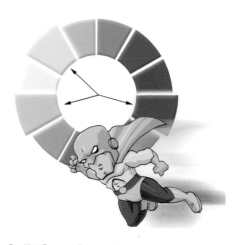

Split Complements

This scheme gives you the best range of color. One color acts as the accent or contrasting color and then you add the two colors on either side of that color's complement. These three colors make up your color scheme.

Monochromatic Colors

Monochromatic color schemes use only one color that can be lightened with white or darkened with black. It is a plain, uncomplicated scheme but can be a little boring.

Triadic Colors

This scheme uses three colors evenly spaced on the wheel. This allows for a wide range of color, but be careful: Only one color should dominate or the scheme will look chaotic.

Coloring Don't

Don't use every crayon in the box. Here the costume becomes just plain distracting. This looks like a job for the fashion police.

computer *Coloring*

Coloring artwork by computer lets you undo mistakes with the click of a mouse and use sophisticated effects that would be difficult and time consuming (if not impossible) to do by hand. Computer coloring is too complex to cover fully here, but the basic process goes like this.

1 Scan your line art into the computer and open it with a graphics editing program. Here I'm using Adobe® Photoshop.®

2 Clean up the line art using the eraser tool and by increasing the contrast of the image. Be careful not to remove important structural lines.

3 Create a new layer for your colors and set the layer to "multiply." (That setting allows colors to be added on top of the line art without hiding it.)

4 Working in the new layer, use the the polygon lasso tool to select an area of the image where you want color to go. Use the fill or paint bucket tool on the selection. Repeat as needed to block in all the basic color areas, or flats.

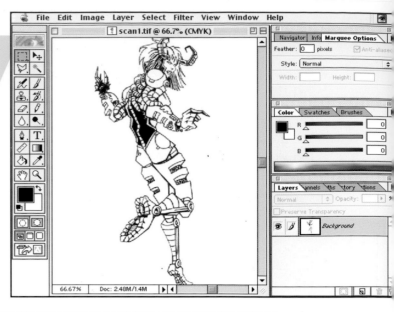

1

2

3

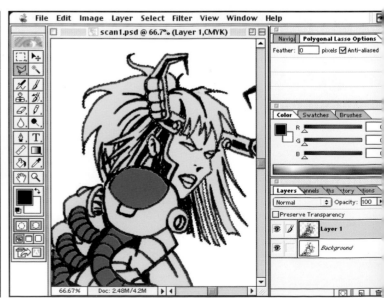

4

5

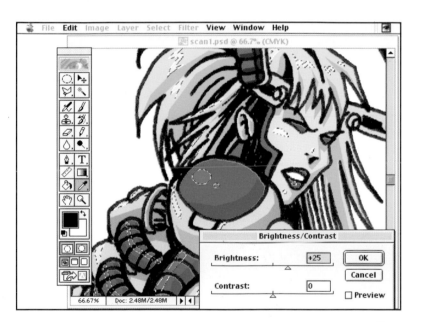

6

7

5 Use the polygon lasso tool to select areas where you want to block in shadows. Then darken these areas. Shadows can be soft or hard.

6 Use the same tool to place areas of highlight, and lighten these areas.

7 Flatten the layers, and you are finished.

colored pencil
Techniques

Colored pencils are readily available and produce very professional results with a minimum of cost and hassle. Here are a few techniques that will enhance your hand-coloring.

Shading and Blending
Using layers of similar colors for shading and blending adds depth and richness to a drawing. Change the pressure for dark and light areas. Blend colors evenly by layering color on color.

Crosshatching for Subtle Shading
Subtle variations in shading can be accomplished by using fine, crosshatched lines.

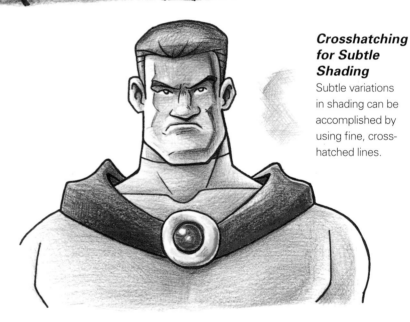

Shading and Lessening a Color's Intensity
Apply shading to or lessen the intensity of a color by adding its complement. Avoid shading with black, which can look dull and lifeless.

Lifting Color
Lift color with an eraser to create highlights and reflections and to lighten areas that are too dark. Erasers can create soft, blended areas of faded color.

Burnishing
Burnishing the surface blends and lightens the colors beneath. To do this, use a white colored pencil over an existing layer of color. The result is smoother, softer blending.

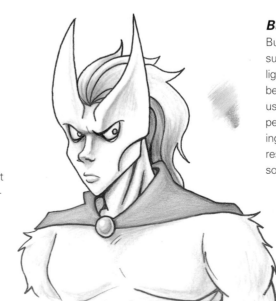

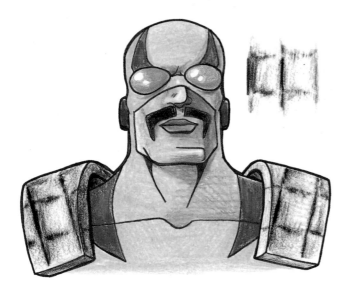

Rubbing

Rubbing existing surfaces can produce interesting textures. Place the paper over the surface and rub with the side of a colored pencil to transfer lettering, shapes and realistic textures.

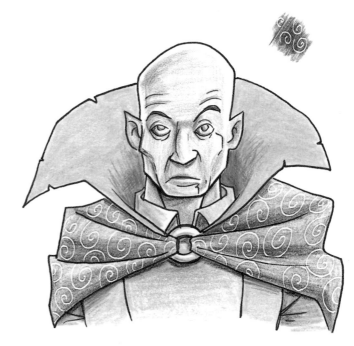

Masking

Use masking tape or pieces of paper to cover areas of the drawing, saving defined edges. This technique is very effective for highlights.

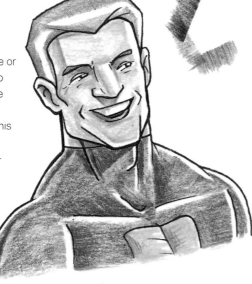

Creating Patterns

Create a pattern of impressions on the surface of the paper using any dull, pointed object. Then lightly shade over the area with colored pencil. White lines will appear where the impressions were made.

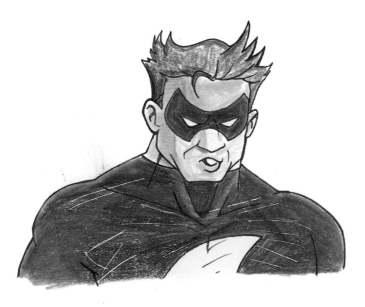

Colored Pencil Don'ts

Ouch! Colored pencils can be trickier to work with than you think. Watch out for smudging; rest your hand on a scrap piece of paper to avoid direct contact with your drawing, keep waxy or powdery buildup off the paper and have an eraser handy. Don't just scribble color into an area; follow the 3-D form of your subject.

Another common problem is ghost lines. These unwanted white lines show up when the surface of the paper has been unintentionally scratched or impressed in any way. It is possible to make some ghost lines disappear by pushing hard when coloring, or burnishing and blending with a white colored pencil.

face

Front View

Not everyone's noggin will look like this, but you've got to start somewhere. There are many variations to the basic formula. Most female characters will have less chiseled features.

1 Draw two horizontal guidelines for the top and bottom of the head. Draw a vertical line, which will be the central axis for the head. Then draw an egg shape that is equal on both sides. Halfway between the bottom of the chin and the top of the head, draw a horizontal eye line.

2 Measure the width of the head along the eye line. It is five eyes wide, with an eye-sized space between the eyes. Draw the eyes roughly almond-shaped, never perfectly round. Place the eyebrows about half an eye above the eyes. Start the base of the nose—which is as wide as one eye—almost halfway between the eye line and the chin. Draw the nostrils as ovals as you see them, not pig-like. The mouth is about a third of the way down from the nose to the chin and is as wide as the combined centers of the eyes. Make the lower lip thicker than the top lip.

3 Place the ears between the top of the eyes and the base of the nose. Draw them on an extreme angle as they rise off of the head to avoid elephant ears. Define the jawline and chin. Make the hair rise off the head with some volume or it will look painted on. The neck typically drops from below the outside corners of the eyes and curves out, but this varies from person to person. Big-bruiser superheroes have meaty necks; teen cub-reporter sidekicks have skinny ones. See page 29 for the finished image.

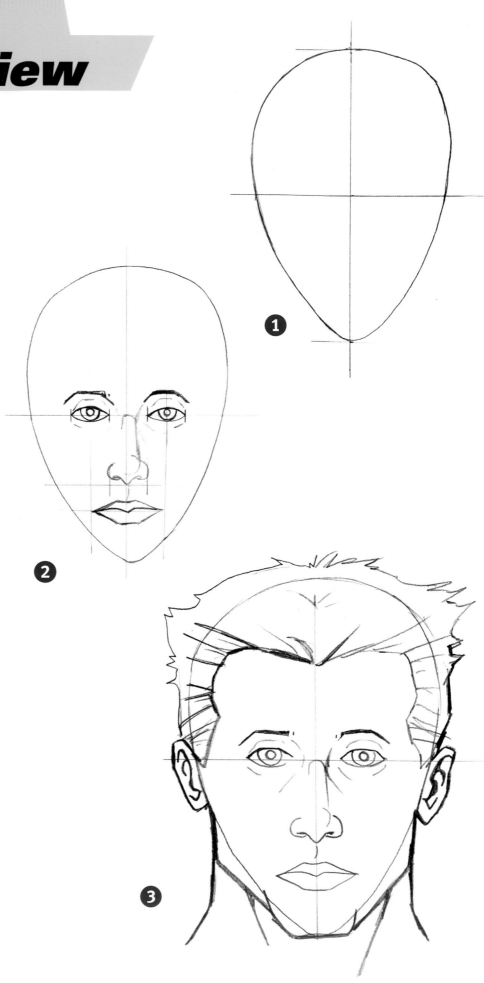

face
Profile

Drawing a face in profile isn't that difficult. You're just looking at things from the side.

1 Draw two horizontal guidelines for the top and bottom of the head. Within these lines draw an egg shape tilted back. Halfway between these lines, draw the eye line. Draw an arrow into the egg shape to represent the eyebrow ridge and the bridge of the nose. Almost halfway between the eye line and the chin, draw the nose line. The nose points up from this line on an angle. Draw the lip line one-third of the distance down from the nose to the chin.

Measure the distance from the eye line to the chin. Measure back along the eye line this distance from the tip of the nose. The ear will be drawn beyond this point. The ear should rise slightly above the eye line and drop down to the nose line.

2 Draw the eye from the side, with the pupil centered on the eye line. Make sure the eye doesn't touch the edge of the face. Draw another arrow into the egg shape to differentiate the top and bottom lips, which should extend from the face. Make the lower lip bigger and rounder. The mouth should extend back to the center of the eye.

3 Block in the eyebrows, with about half an eye space between the eye and the eyebrow. The nose should not be too pointy or too round. Draw the nostril as a thin oval that doesn't touch the front of the nose shape. Add the details of the ear and sketch the hair as it rises off the head. Define the jawline and chin. Draw the neck at an angle from the base of the skull and the chin just below the eyes; don't just let it drop straight down. See page 29 for the finished image.

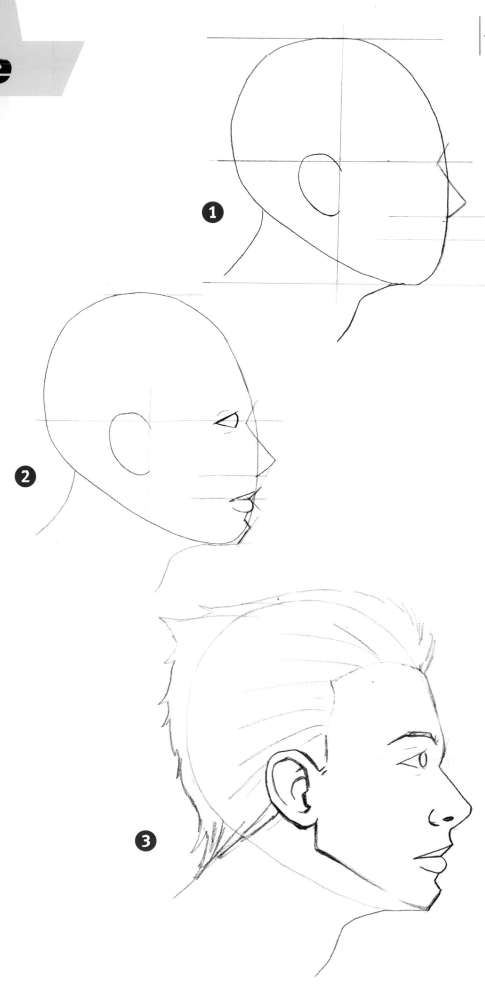

face
3/4 View

*T*his is one of the most challenging but most commonly drawn views of the face. The facial features will be somewhat distorted from the positioning of the head. The features will appear to rise off of the face.

1 Draw two horizontal guidelines for the top and bottom of the head. Draw two egg shapes within these lines: the first upright and the second slanting to one side. The left line of the second egg becomes the central axis of the face. Halfway down the axis, draw the eye line. Roughly halfway between that and the chin, draw the nose line. Add the lip line one-third of the distance down from the nose line to the chin.

2 Block in the eyes and eyebrows. Draw an arrow into the egg shape to represent the eyebrow ridge. The closest eye should be slightly larger and less distorted. The nose should rise up off of the face. The nostril we see should start at the inside corner of the right eye, and the tip of the nose almost touches the far cheek. The center of the lips will be along the central axis. Draw the far side smaller than the near side.

3 Define the chin and the jawline. Measure the distance from the eye line to the chin. Measure back along the eye line this distance from the central axis. The ear will be drawn beyond this point. Extend the eye and lines so they curve around the head; the ear will meet the top of the eye line and drop down just below the nose line. Draw the ear at a slightly distorted angle, not a true side view. Make the hair rise up off of the skull, and block in the neck from the area just behind the ear and the center of the chin. Curve out the edges of the neck as it drops down. See page 29 for the finished image.

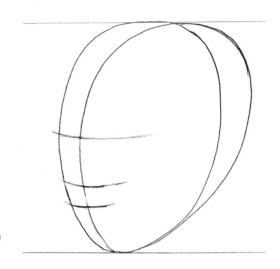

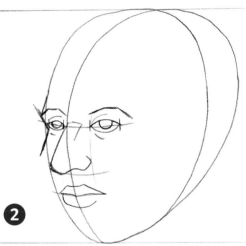

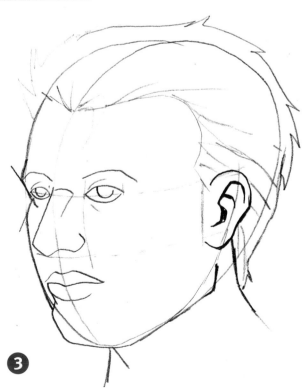

face Shading

Define the shapes and planes of the face, such as the nose and cheekbones, by using shading and highlights. Remember that the face is really just a collection of 3-D shapes, and some of these shapes will cast shadows onto areas of the face. Don't forget to keep your light source consistent!

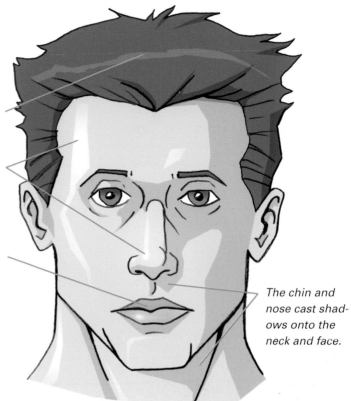

The hair highlight should follow the shape of the head.

Highlights should help define the basic shapes of the skull and nose.

The top lip is shaded darker than the lower lip.

The chin and nose cast shadows onto the neck and face.

Don't forget to shade the hair.

This highlight reflects the basic form of the skull.

Ears and eye areas have shadows, too.

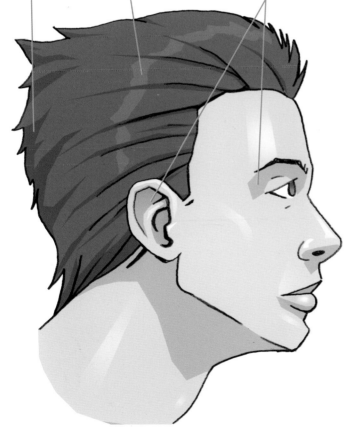

Observe facial structure, including cheekbones, when shading the face.

As the details of the hair become more specific, so do the details of the highlights.

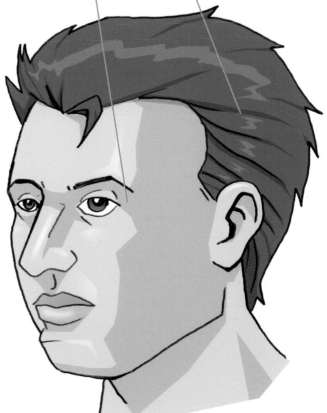

face **Details**

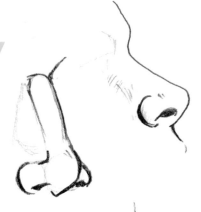

Practice drawing the details of the face whenever you can. Combining these elements into an agreeable order is what makes the face look convincing.

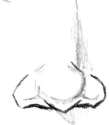

Noses

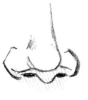

The nose should rise off of the face. You only need a few lines to indicate a nose. Draw the nostrils as thin ovals or lines, never as pig-like circles.

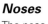

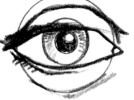

Eyes

The basic structure of the eye can be seen in these images but will vary from person to person. The top eyelid covers the top third of the eyeball. The pupil should rest on the lower eyelid and be partially covered by the upper eyelid. Notice how the shape changes dramatically when viewed from different angles.

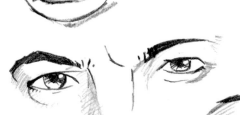
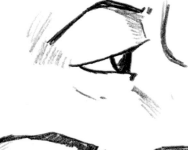
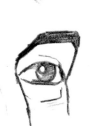

Mouths

The center of the mouth should be a bow shape that points down on the central axis of the face. The upper lip should be much thinner than the lower lip. Refer to photos and models to practice drawing different kinds of open and closed mouths.

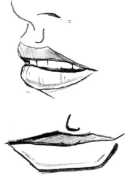

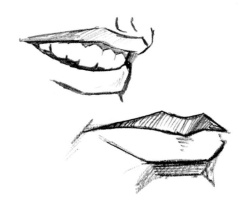

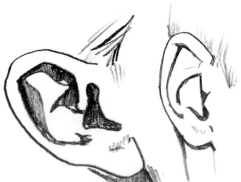
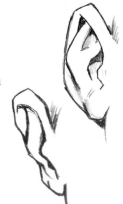

Ears

The shapes inside the ear can be puzzling to draw, but the details can be simplified. Pay attention to the overall shape of the ear and how it changes when the head is seen at different angles.

expressing
Emotions

Whether they have to face cosmic, life-altering events or learn the hard way how to use their amazing powers responsibly, superheroes have big adventures and deal with big emotions. Here are some ways to express emotion through the face.

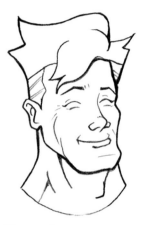

Pleased
Closed eyes, raised eyebrows and a grin.

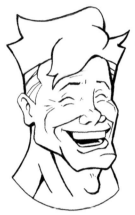

Laughing
Closed eyes, raised eyebrows, laugh lines and a wide-open, toothy mouth.

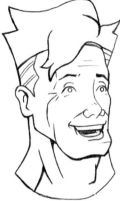

Happy
Open eyes, raised eyebrows, forehead lines and a slightly open mouth.

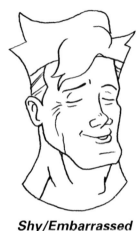

Shy/Embarrassed
Closed eyes, slanted eyebrows, pursed lips and a slightly open mouth.

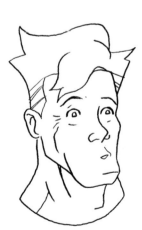

Shocked
Wide-open eyes with small pupils, raised eyebrows and an O-shaped mouth.

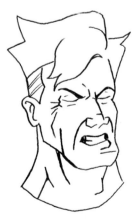

Frustrated
Tension lines surrounding closed eyes, slanted eyebrows, clenched mouth and a curled-up nose.

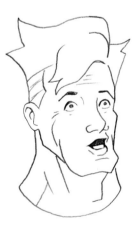

Worried
Wide-open eyes, raised eyebrows, forehead lines and an open mouth.

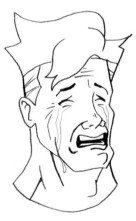

Crying
Slanted eyebrows and eyes, lots of forehead lines, tears streaming from closed eyes and a wide-open mouth.

Sleepy
Narrow, small eyes; raised eyebrows (attempting to keep the eyes open); exaggerated lines under the eyes, and a small, slack-jawed mouth.

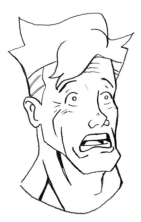

Frightened
Tension lines surrounding super-wide eyes with tiny pupils, forehead lines and a mouth open in a gasp or scream.

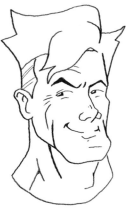

Sly
Shifty eyes, slanted eyebrows, forehead crease and a lopsided grin.

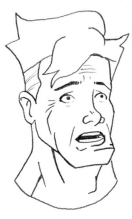

Confused
Wide-open eyes, raised eyebrows, many forehead lines and a mouth open as though the person has tried to speak but is at a loss for words.

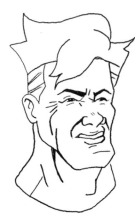

Disgusted
Squinted, narrow eyes; slightly slanted eyebrows; turned-up nose, and tightly pursed lips.

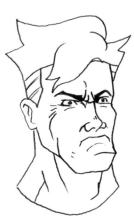

Annoyed
Slightly narrow, intense eyes; slightly slanted eyebrows; forehead crease; frowning mouth with tight lips, and a clenched jaw.

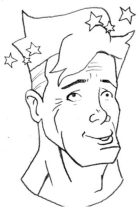

Stunned
Spacey eyes, raised eyebrows, forehead lines, beak-like lips and possibly stars surrounding the head.

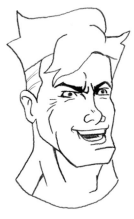

Cocky
Angry/annoyed eyes, slanted eyebrows, forehead crease, and a tight, unfriendly smile.

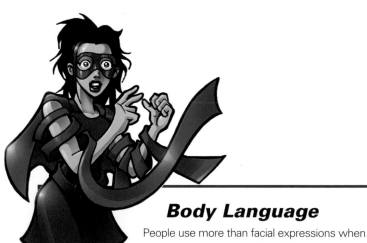

Body Language
People use more than facial expressions when they communicate emotions. The pose and attitude of the body can speak volumes. Some actors find that they can express themselves better if they adopt a signature pose or type of movement for the character they are playing. This visual shorthand communicates mood, attitude and personality without even uttering a word. A good comic artist is part director and part actor, revealing character through expression and body language.

heroic **Proportions**

Superheroes are larger than life, but you should follow some rules regarding proportions. Start by learning the proportions of realistic humans, then see how the proportions change (or don't change) for classic super-heroes and superhumans. You may need to make changes to suit more extreme characters but it is important to understand the basics of creating consistently proportioned characters before you begin breaking the rules.

Adult Male
The differences among the propor-tions of the realistic figure, the classic superhero figure and the superhuman figure are striking.

Realistic adult males range from 7.5 to 8 heads tall.

Classic superhero adult males range from 8 to 8.5 heads tall.

Superhuman adult males range from 9.5 to 9 heads tall.

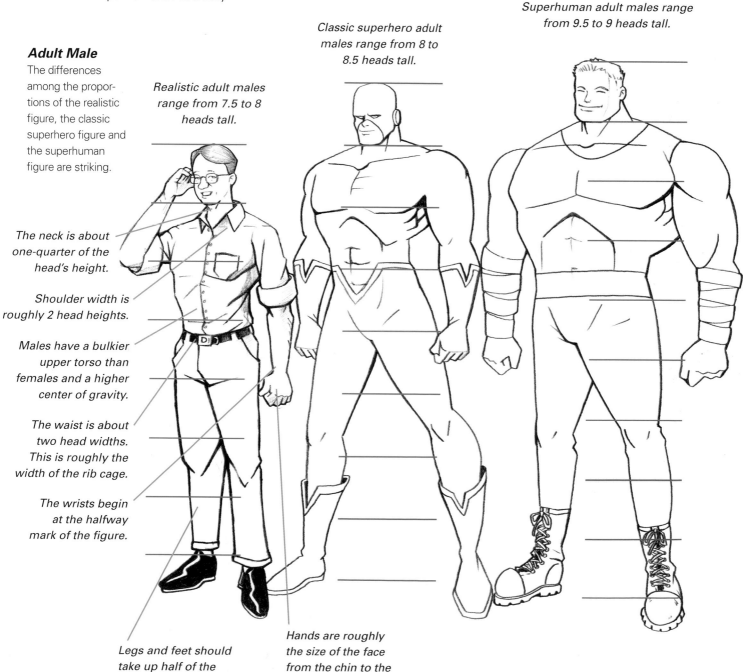

The neck is about one-quarter of the head's height.

Shoulder width is roughly 2 head heights.

Males have a bulkier upper torso than females and a higher center of gravity.

The waist is about two head widths. This is roughly the width of the rib cage.

The wrists begin at the halfway mark of the figure.

Legs and feet should take up half of the total body height.

Hands are roughly the size of the face from the chin to the eyebrows.

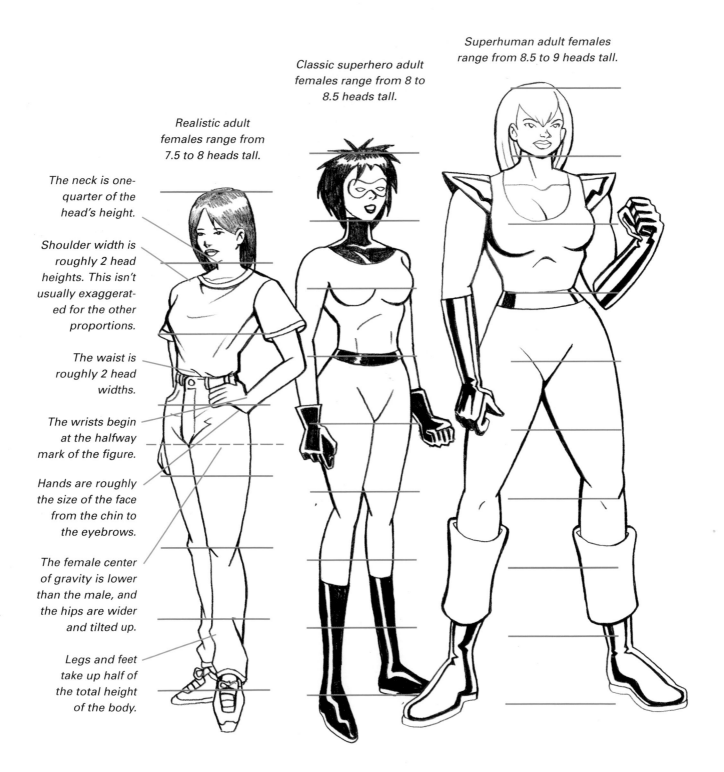

Superhuman adult females range from 8.5 to 9 heads tall.

Classic superhero adult females range from 8 to 8.5 heads tall.

Realistic adult females range from 7.5 to 8 heads tall.

The neck is one-quarter of the head's height.

Shoulder width is roughly 2 head heights. This isn't usually exaggerated for the other proportions.

The waist is roughly 2 head widths.

The wrists begin at the halfway mark of the figure.

Hands are roughly the size of the face from the chin to the eyebrows.

The female center of gravity is lower than the male, and the hips are wider and tilted up.

Legs and feet take up half of the total height of the body.

Adult Female

Variations in female proportions are just as dramatic as in adult males. The female figure may have defined muscles, but female superheroes are rarely as muscular as male superheroes.

Teens range from 7 to
7.5 heads tall.

Teens

These proportions can apply to
smaller adults, too. Some teens
will appear younger and less
physically developed, while
others may have more adult
traits.

*Shoulder width is about 1.5
to 2 head heights, and they
are often more narrow and
rounded than adult shoulders.*

*Facial features
(such as a rounder
face or larger
eyes) may be
exaggerated.*

*The build of the torso
and musculature is
toned down and less
angular than adults.*

*The hips are
usually just as
wide as the adults'
but are more fluid
and expressive.*

*The wrists begin
at the halfway mark
of the figure.*

*Children range from 4.5 to
5 heads tall but can change
quickly as they age.*

*The eyes are typically
large and expressive.*

*The neck is about
one-quarter of the
head's height and
looks thinner because
of a larger head.*

*Hands and feet
seem larger because
the rest of the body
is less developed.*

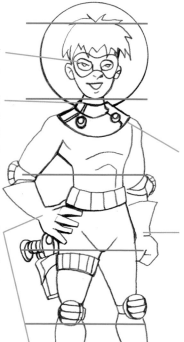

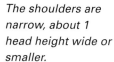

*The shoulders are
narrow, about 1
head height wide or
smaller.*

*The wrists begin at
the halfway mark of
the figure.*

*The more muscular
the child, the less
childlike they will
appear.*

Children

Children have been drawn as side-
kicks and as heroes in their own right.
Children with strange powers often
appear in comics.

extreme **Proportions**

Comic books allow totally wild variations of the figure for characters. Pretty much anything goes, as long as you are consistent. Compare these extreme characters to the classically proportioned superhero (in shadow).

The unusually thin and lanky robot on the far left doesn't seem as tough as the ape-bot in the center or the steam-driven nightmare on the right.

Robots are a perfect excuse to use unusual body shapes. In comics you are perfectly welcome to encourage form over function. Making robots look cool is usually more important than making them look realistic. You can explain away the design features after you draw them.

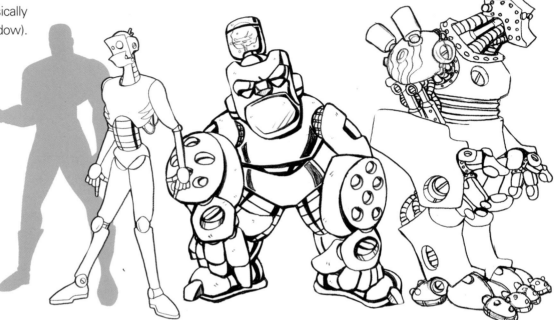

Stretchable characters have been around almost as long as superhero comics. The artistic flexibility of stretching powers can create some very unusual and hilarious images and stories.

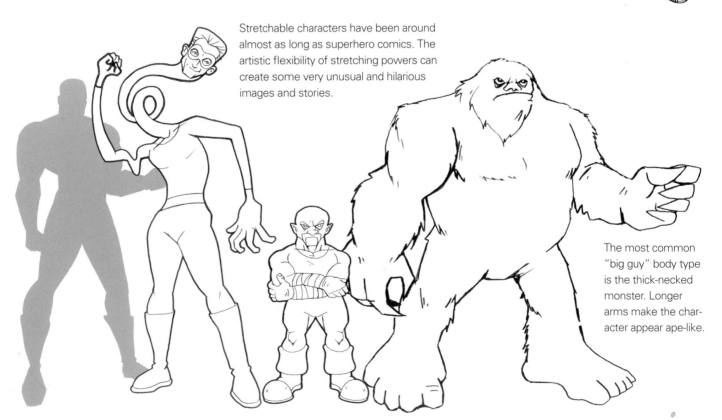

The most common "big guy" body type is the thick-necked monster. Longer arms make the character appear ape-like.

Stocky dwarf characters are typically found in fantasy comics, but short-statured heroes can also show up in superhero comics.

drawing
Hands and Feet

Drawing hands realistically can be an extremely frustrating chore. This is where many drawings break down. You can only draw your superheroes with their hands hidden so many times. Many artists also avoid drawing feet. Approach hands and feet like any other part of the figure: Reduce the forms to simple shapes and then add details.

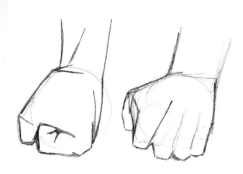

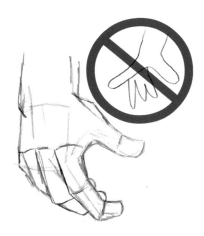

A Fist With Punch
When drawing a fist, keep the thumb up over the fingers. If your superhero punched the villain with his thumb tucked under the fingers, the thumb would break.

No Banana Hands!
Many artists create shortcuts and symbols to get around drawing hands. This is fine for a while, but it doesn't really solve the problem.

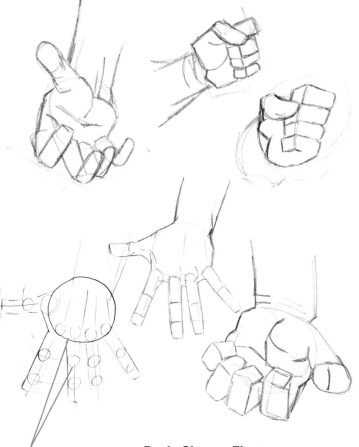

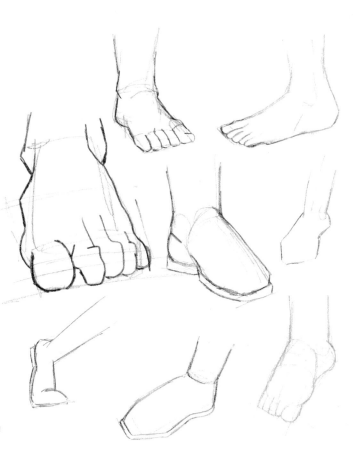

The length of the longest finger is roughly the same size as the palm.

Basic Shapes First
Hands are made up of basic shapes. Once you understand the basic building blocks of the hand, you can draw it in a variety of poses.

Make Sure the Shoe Fits
Draw footwear with the basic shape of the foot in mind. The shoe should follow the form of the foot. Keep references handy so you can add realistic details such as soles and laces.

Costume
details

The best way to design a costume is to think of the concept and work around it. For example, the detective hero Minerva stalks the dark alleys and streets of the city in her quest for justice and truth. She is part of a larger organization that traces back its history of crimefighting to the ancient Greeks and Romans. The third person to call herself Minerva in the past one hundred years, she is new to the job and nervous about the challenges she will face in the future. Let's make her a costume.

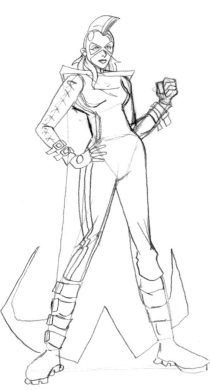

First Sketch
The early sketches for Minerva depict her in a one-piece suit with many buckles and stitches. This gives her costume a slight gothic feel. The "fin" on her head refers to the helmets worn by ancient Greek warriors and statues of the goddess Athena (Minerva to the Romans).

Minerva needs a mask to conceal her identity. She has many enemies, and she doesn't want them threatening her loved ones. Her cape, which forms the letter "M" as she leaps across the night sky, provides a stretchable glider to slow her descent.

Refining Details
Sketching the costume from the back allows you to further explore the details. Spikes on the elbows might cut the glider cape, so they're not such a good idea. The elaborate grips on the soles of the boots and the stitches seem too complicated for a character that will be drawn roughly four times a page.

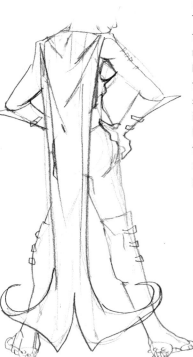

Coloring Ideas
The final colored sketch captures Minerva's attitude and reveals some of the challenges of finishing the costume. Her dark outfit, a must so she can easily disappear into the shadows, is made of highly polished leather. Carefully placed highlights and reflections are needed to portray this shiny surface.

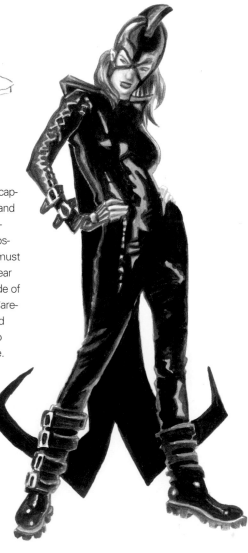

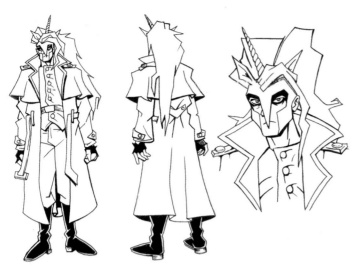

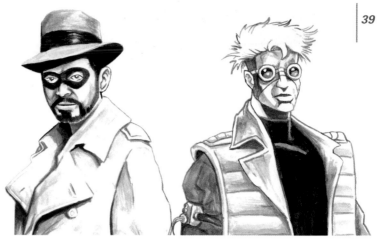

Create Model Sheets

Create model sheets showing your characters from many different angles to keep costume details consistent as you draw them panel after panel. Keeping the character "on model" means that you are paying attention to details such as the number of buttons on the shirt, length of hair and so on.

Masks

Masks are usually used to hide a character's true identity. The classic domino mask is small and black. More functional goggle-like masks conceal the wearer's identity but can also enhance vision or protect the eyes. As difficult as it is to believe in real life, most people in a comic book world have a hard time recognizing the secret identities of super-heroes no matter how small the mask may be.

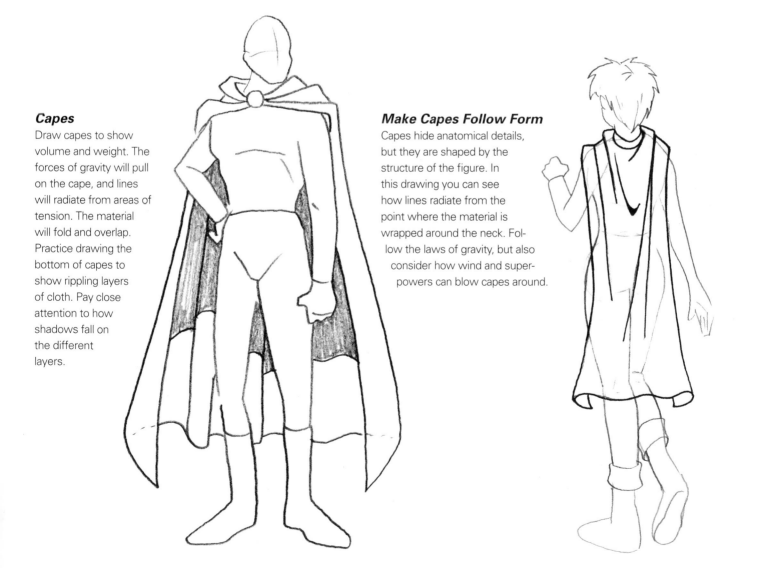

Capes

Draw capes to show volume and weight. The forces of gravity will pull on the cape, and lines will radiate from areas of tension. The material will fold and overlap. Practice drawing the bottom of capes to show rippling layers of cloth. Pay close attention to how shadows fall on the different layers.

Make Capes Follow Form

Capes hide anatomical details, but they are shaped by the structure of the figure. In this drawing you can see how lines radiate from the point where the material is wrapped around the neck. Follow the laws of gravity, but also consider how wind and super-powers can blow capes around.

Foreshortening

Foreshortening allows the artist to freeze time and create some of the standard heroic poses we expect in a superhero story. Quite simply, what is closer to the viewer appears larger than what is farther away, and things that are near will overlap what is behind. You can see foreshortening when you point your arm at a mirror. Your hand and forearm look bigger in comparison with the rest of your body.

Superhero comics use foreshortening to enhance the action and exaggerate the perspective. This makes the images more dramatic and superhuman.

Foreshortening Draws Viewers In

This figure is seen from an unusual angle. There is a real sense of the figure's position in space. The arm that is farther away looks smaller; the closer arm looks bigger and comes right at the viewer.

How's the View?

Foreshortening can reveal something about the character in a story. Changing the regular point of view and looking down at the figure makes him appear smaller and less powerful than if we were looking up at him.

Better

This pose is very dynamic. The face is closer and the legs almost disappear behind the torso. The pose is more urgent and pressing. She's flying right at you!

Boring

This flying pose is powerful but a little boring. It does the job but isn't very dynamic.

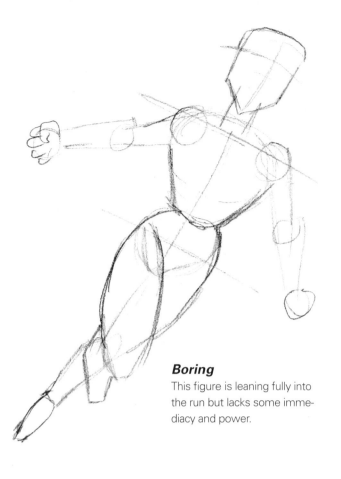

Boring

This figure is leaning fully into the run but lacks some immediacy and power.

Better

This figure is definitely running right at us. The most exaggerated part of the figure is her right fist. We know it is closer to us than the left hand because it's bigger. Her right leg is lifted and the foot is hidden behind the thigh.

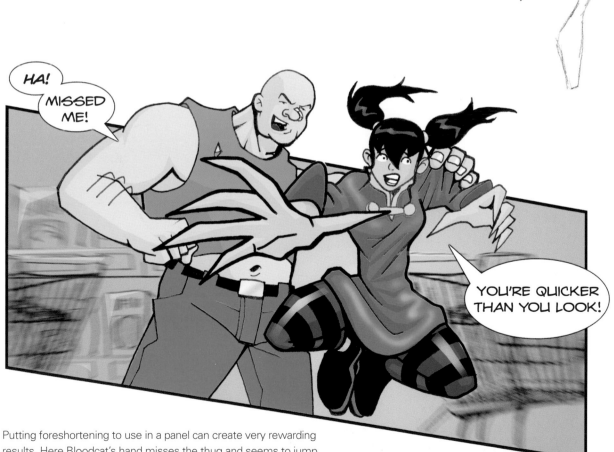

Putting foreshortening to use in a panel can create very rewarding results. Here Bloodcat's hand misses the thug and seems to jump off the page toward the reader. The large claws appear closer and more dangerous.

superpowers and Special Effects

*T*he depiction of superpowers is limited only to your own imagination. Just remember that your superpowers should truly look super.

The blasts and explosions resulting from some superpowers are going to have an effect on the setting. Energy blasts and super-powered fists will rip holes in walls, shatter glass and generally trash the landscape.

Energy Blaster
Firing blasts of energy is a common superpower. These blasts can emit from the hands, eyes, mouth or even the hair of the superhero. There is often a glow around the source of the blasts to show the intensity of the power.

Glowing Hands
Glowing hands are also common for characters using magic or mental powers such as mind control. This visual shorthand lets the reader know that the character is using the power.

A Natural Gift
Sometimes the power is an easily identifiable natural element such as fire or water. Even though the hero might be immune to the fire, his clothes could still get burned.

Bullet Holes

These add a sense of realism and menace to a scene.

Energy Blasts

Blasts of energy exploding across the ground toward the hero create visual excitement and dramatic imagery. Add small fragments of debris for realism.

The Aftermath

Explosions and strikes can tear apart the landscape, leaving huge, smoldering craters. The ground seems to shatter and rise up, spreading debris in all directions.

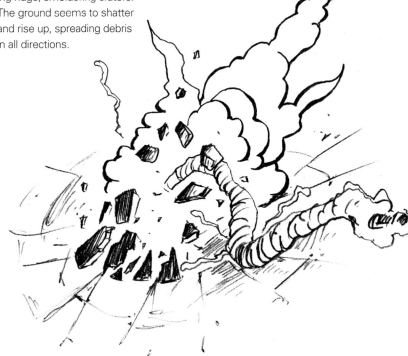

Machine-Gun Blasts

Some blasts can be simple and direct like this string of multiple machine-gun hits. You can almost hear the bullets ricochet.

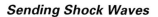

Sending Shock Waves

Super-strong characters can easily toss trucks around, but they can also use their powers in other ways that are just as effective. Slamming both fists on the ground can create a shock wave that knocks the bad guys off their feet and sends walls tumbling down.

props *and* Weapons

Sure, some superheroes can fire bolts of energy from their hair, but others rely on props and weapons to combat evil. It is important to realistically draw how the character carries and handles these objects.

Support Action With Body Language

When lifting very heavy items, the hero should strain against the weight. A strained face will show clenched teeth and a wrinkled forehead. The muscles should seem to cry out against the effort. The less the character seems to strain against the weight, the more powerful he will appear.

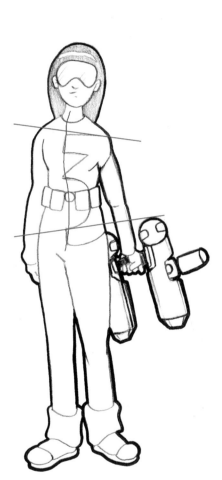

Position Hands to Suit the Weapon

Holding weapons requires a bit of thought or research to make it look right. Some weapons like this dart pistol are held in the same way every time because that's how they are built. The reader expects it to be held this way.

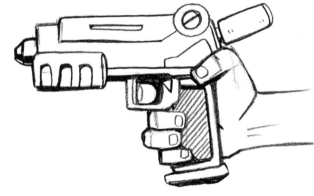

A Weighty Subject

Consider the weight of the object the character is holding. Even super-strong characters should adjust their stances to support lifting heavy items. There will be a tilt to the shoulders and an opposite tilt to the hips to take some pressure off the spine.

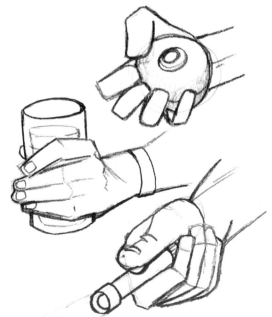

Wrap It Up

The hand and fingers should appear to wrap around the object being held.

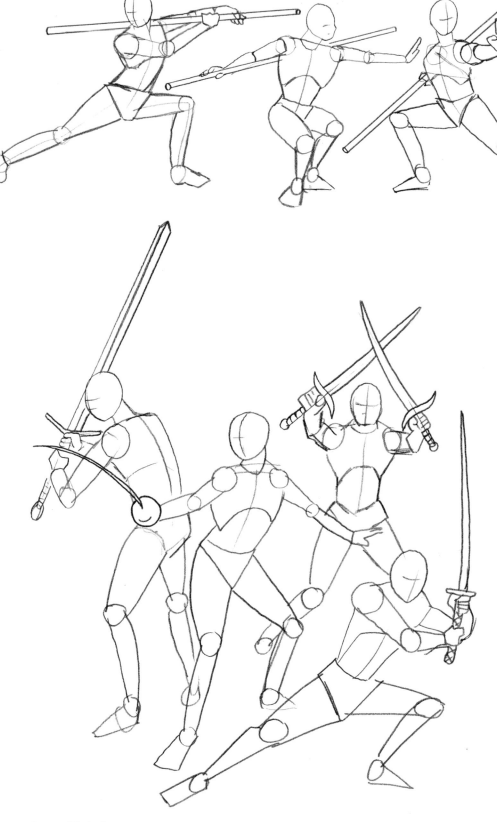

Weapons as Extensions of the Body

Weapons wielded by martial artists become an extension of the warrior. The movements should appear fluid and graceful. This sequence shows a shift in stance and how the weapon is held. Swing a broomstick around to see what feels and looks natural, just be careful!

Learn From the Masters

Look at photos or videos of martial artists using the weapons you want to draw, or take martial arts lessons yourself. You really get a sense of what you can and can't do when you actually experience swinging a pair of nunchaku with proper instruction.

Research Your Weapon

Specific weapons, like the sai, are held in certain ways depending on the martial art or the circumstances. Again, any research you can do before you start drawing will help.

Swordfighting

How a sword is handled depends on the fighting technique. Scottish claymores were nothing more than sharp clubs, relying on brute strength and chopping power. Fencing, on the other hand, is a very controlled method that uses light swords and specific stances and strategies. Double swordfighting is more fantasy than reality, especially using two swords of the same size and weight. It's impractical but looks cool. Ninja warriors combine martial arts with simple but effective sword techniques.

the ultimate Hero

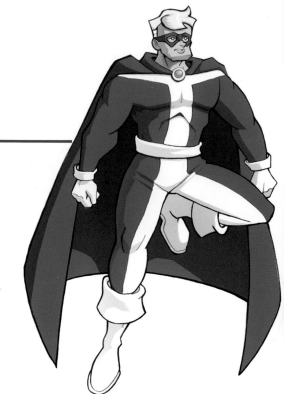

The Ultimate Hero is the toughest hero on earth. Whenever there is a problem the Ultimate Hero is there to save the day. He's been around for a few years and has been an inspiration and mentor to countless other heroes.

Like the ancient Greek hero Achilles, the Ultimate Hero often has a weakness that renders him powerless. It could be a special type of space rock or chemical, magic or technology. Inventing the details of the weakness is part of the enjoyment of creating this character. It's not very interesting if the Ultimate Hero always saves the day unless he really has to work for it.

Character Profile

Name: The Scarlet Avenger

Origin: Former test pilot was bathed in cosmic rays to become one of Earth's mightiest heroes.

M.O.: Always fights fair and tries to be a positive force in the world.

Powers: Super strength and invulnerability. Fires bolts of cosmic energy from his hands.

Weaknesses: Susceptible to modified cosmic radiation. Long history of villainous enemies comes back to haunt him.

1 Create a strong line of action and then use sticks, ovals and circles to create the basic figure. This character is very broad chested and powerful. Exaggerate his proportions by making the chest bulkier and the shoulders wider. Notice the foreshortening of the pose: The arms are closer to us and therefore look much bigger than the legs.

2 Add muscle mass to the figure. Make him beefy! Keep things loose at this point. Block in the feet and hands and define the hips and torso. I've tried to create a character that is strong and blocky.

3 Add costume and anatomy details over the musculature. Draw the details of the hands, feet, torso, neck and hips. He has a secret identity to protect, so give him a mask. Keep the lines of the cape flowing from the specific points of tension where it is attached to the costume. He's been a hero for a long time, so his costume is traditional and somewhat old-fashioned.

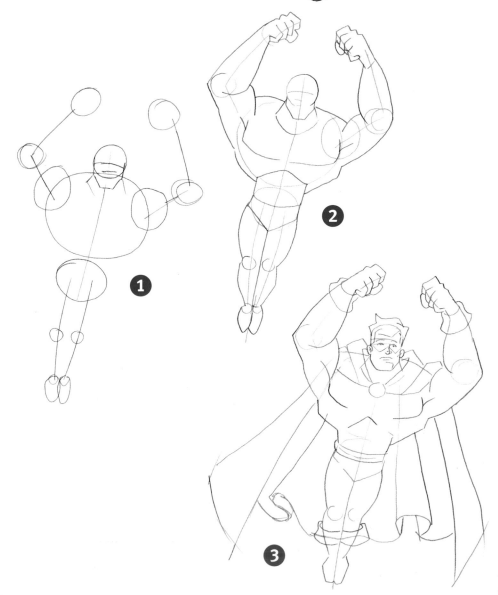

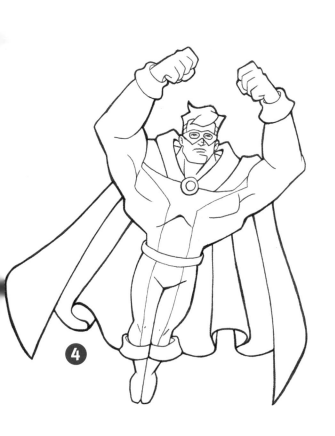

4 Simplify and exaggerate the muscles. He should appear big and strong but not monstrous. Erase the light guidelines and develop the costume details. The billowing cape makes him look even bigger.

5 Finish the drawing with colored pencils. Have a clear idea of where your light is coming from as it falls on the figure, and don't forget the reflected highlight on the other side of him. Choose a costume color that is bold and heroic. The Ultimate Hero doesn't have to hide in the shadows. He should be flashy and stylish, standing out in the crowd.

Ultimate Options

The Ultimate Hero might have an evil twin or clone such as Dark Avenger lurking in his shadow, jealous of the hero's never-ending presence in the spotlight. The hero could be a female such as Pink Fury, carving out her own reputation as a powerful crimefighter. Another popular variation is Power Kid, combining earth-shattering power with teen attitude.

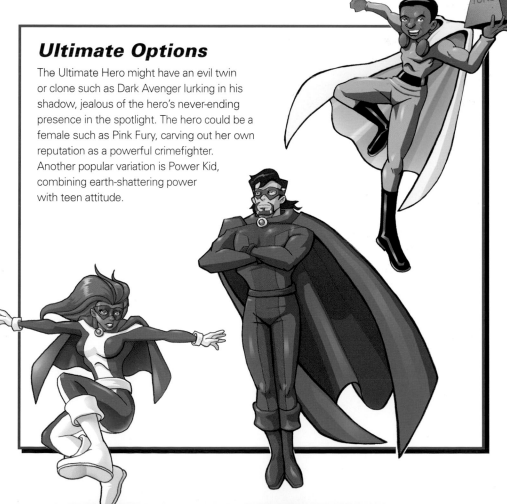

the arch Villain

The Arch Villain is one of the most powerful enemies the superhero will ever encounter. The origins of the main superhero and the Arch Villain are usually linked, creating an instant conflict between them. The hero should always appear to be overwhelmed by the power and magnitude of the Arch Villain as the story progresses.

Arch villains should have earth-threatening goals of power, conquest and destruction. The heroes must have a really good reason to risk their necks time after time. The black-hearted Arch Villain is almost always defeated when the hero exploits some little-known weakness or character flaw and foils his dastardly plans. But the defeat of the villain should never be the death of the villain. Buildings might collapse around them, but no body should ever be found. The villain should always have a chance to return again another day.

1 Block in the basic structure. Even though Sir Skull is a disembodied spirit, you should still block in where his legs would be. His fingers are long and claw-like. He is leaning back as if he is floating.

2 Begin adding the misty darkness that surrounds Sir Skull, making up his lower torso. The tendrils of darkness should appear to be snaking out in all directions. Block in other anatomy and costume details, referring to references for ideas.

3 Finalize the details of the costume and anatomy, keeping them as consistent as you can. The darkness should appear solid and impenetrable. The tendrils should be fluid; the fact that they appear to be dripping upward adds eeriness to the image.

Character Profile

Name: Sir Skull

Origin: 500-year-old evil spirit of insane highwayman

M.O.: Possesses his victims, turning them into violent criminals. Involved in crimes pertaining to bones or tomb treasures.

Powers: Darkness manipulation and illusions. Spiritual possession and control.

Weaknesses: Mental attacks, direct sunlight.

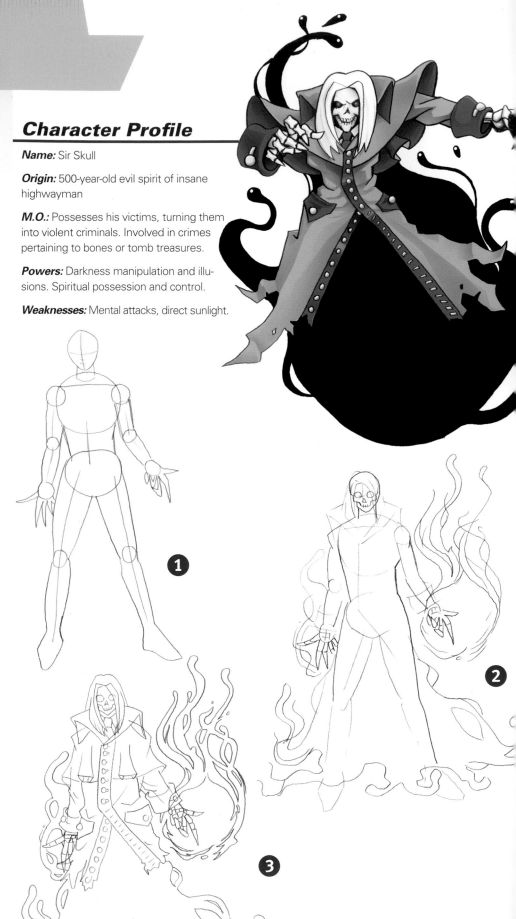

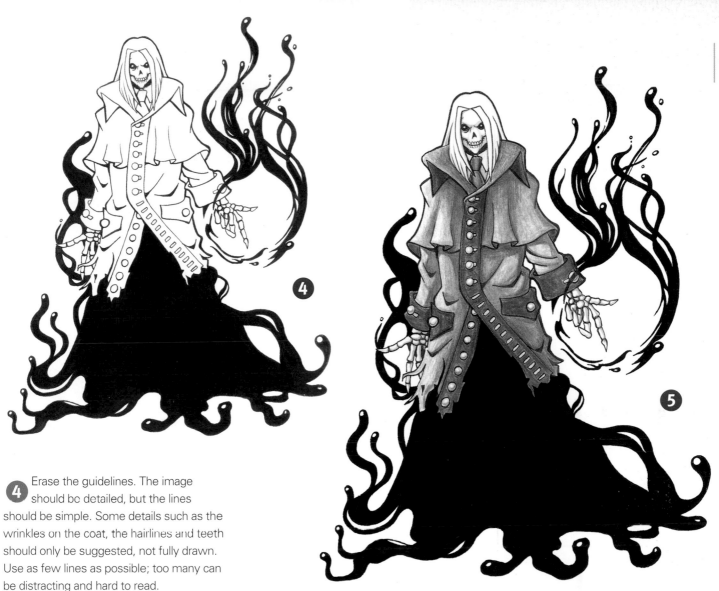

4 Erase the guidelines. The image should be detailed, but the lines should be simple. Some details such as the wrinkles on the coat, the hairlines and teeth should only be suggested, not fully drawn. Use as few lines as possible; too many can be distracting and hard to read.

5 Watch the coloring of fine details such as the finger bones and brass buttons. Make sure that they appear 3-D and realistic. Keep the highlights and shadows consistent with the direction of the light source. Keep the colors simple and muted. Too many colors would be inappropriate for a creature of darkness like Sir Skull.

Assorted Villainy

Some Arch Villains are more flashy than scary. Zorth enjoys making overblown speeches and billowing his cape dramatically. Dark Minerva is cool, calculating and dangerous. She has all the training and knowledge of Minerva—the Detective Hero you'll draw next—but she also possesses magical relics that give her the powers of the ancient Roman gods.

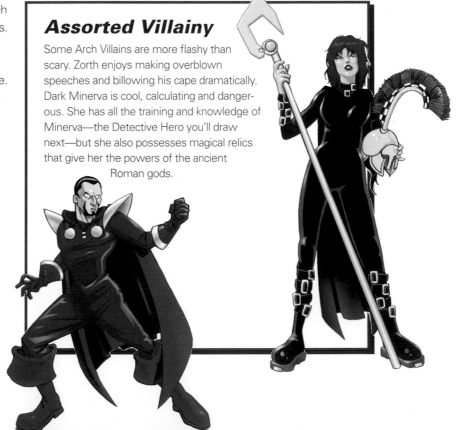

the detective Hero

The Detective Hero is a tireless investigator. Although she usually possesses no superhuman abilities, she has been trained to the peak of human ability both physically and mentally. Her lack of powers doesn't stop her from jumping into the most challenging cases against powerful villains. There is often a wide range of weapons, tools and gadgets available to the Detective Hero to help level the playing field. She usually works alone, but a sidekick or two may assist her at times.

The Detective Hero is one of the oldest character types in comics. Many of the most popular superheroes were originally featured in detective or crime comics. The key motivation of the Detective Hero is acting as an agent of vengeance or defender of the innocent. This driving desire for righting wrongs makes it difficult to have a "normal" life, especially when she can't rely on superpowers. Every spare moment is devoted to research, training and pursuing leads—anything to give her the edge against her superpowered foes.

1 Draw a single guideline for the spine to show the line of action. This line continues along the figure's left leg. She is leaping up and forward from a crouching position, so the torso overlaps the abdomen. Keep the line of action fluid and smooth to reflect the springiness of the pose.

2 Don't make her too muscular, but give her arms and legs some form. She should appear graceful and quick, not blocky and chiseled. Her power comes from the coiled tension of her pose, not necessarily her muscles. Keep the knees and the feet pointed in the same direction.

Character Profile

Name: Minerva

Origin: The latest in an age-old line of crimefighters supported by a secret organization that follows the doctrine of Minerva, the Roman goddess of wisdom and war.

M.O.: Tireless investigator with access to a global information support network. Uses various gadgets and weapons in a war on crime.

Powers: Possesses no known superpowers but has trained physically and mentally to maximum human potential.

Weaknesses: Single-minded devotion to crimefighting allows no time for a social life or relationships. Minerva has many old enemies who seek revenge.

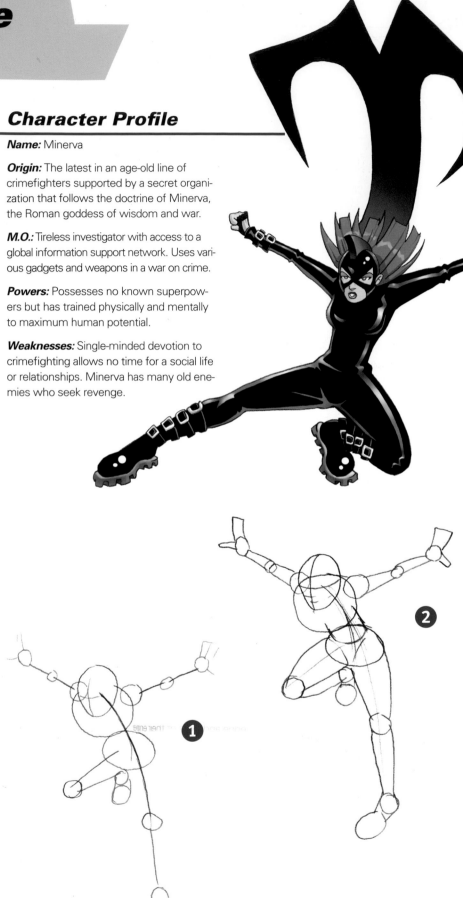

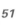

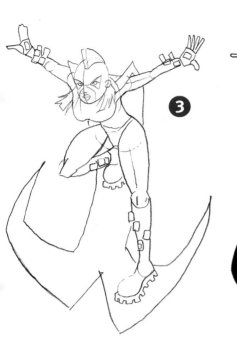

③ Erase some guidelines and then add costume details such as the mask, boots and cape. Note the unique eyeholes on this mask and the distinctive "fin" on the top of the head, which refers to the helmets worn by the ancient Greeks.

④ Clean up all sketchy lines and start defining muscle and costume details. Her distinctive cape splits in the middle and rises up on the sides to create handles when the cape is used for gliding. The cape also dramatically creates the letter "M" as she falls. Fill in the dark areas and leave highlights to express the shiny nature of her leather costume.

⑤ Keep the highlights bright. Figures drawn with large areas of black run the risk of appearing flat, so the highlights are very important to define the figure and details such as the buckles on her arms and legs, as well as the flow of her cape. Her muted and mysterious colors allow her to easily disappear into the shadows.

Detective Alternatives

The Detective Hero may take many forms, such as the traditional child detective hero Little Mystery and the crimebuster genius Apetorney. The duo known as Illuminatus were complete strangers who, when they met, gained the collective knowledge and skills of their entire society.

the tough Villain

The Tough Villain is the adversary that superheroes face on a regular basis. The lieutenant of the Arch Villain, he ends up doing all the dirty work. This character must be defeated before the heroes can get to the Arch Villain. Much stronger than a lone hero, it often requires the teamwork of several heroes to overcome him.

In ancient myths, the Tough Villain was usually a guardian monster that tried to stop the hero from completing the quest. Keep the readers guessing by making it appear as if the Tough Villain is defeated, only to have him rise again to battle some more.

1 Start loosely with large, rounded shapes. Be more expressive than realistic. Bend the rules of anatomy and proportion to make him appear stronger and inhuman. Make his neck, hands and feet large and powerful.

2 Block in the details. The body should be bulky and thick but still appear fluid and mobile. His mouth should be sneering, and his attitude or swagger should be obvious even at this stage. Even though the Tough Villain is exaggerated and simplified, it should still have a sense of 3-D structure.

3 Avoid adding unnecessary anatomy and costume details. His face and body are simplified, and the only costume visible is flame. Give him scowling eyes and a heavy brow ridge.

Character Profile

Name: Magma Menace

Origin: Geologist studying lava flows was exposed to deadly volcanic gasses. Instead of dying, his latent mutant powers transformed him into a monster.

M.O.: Magma Menace likes to crush and burn whatever gets in his way.

Powers: His body temperature is a scorching 1,000 degrees centigrade. He burns whatever he touches. His liquid form can squeeze between the cracks of what he can't burn through.

Weaknesses: Susceptible to cold and water attacks. Will turn to stone if covered in water or starved of oxygen.

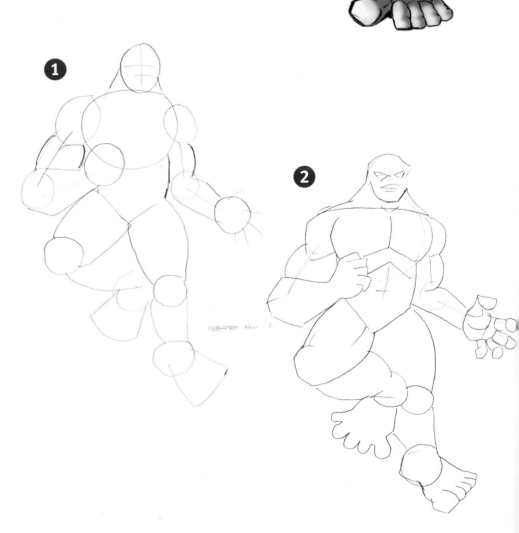

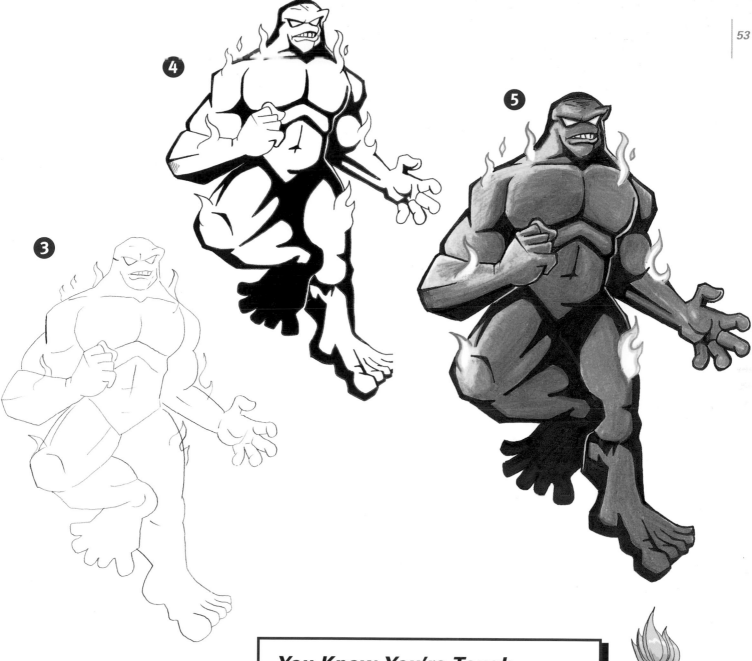

4 As Magma Menace is a creature of living magma, he creates some of his own light. Make the contrasts of light and dark dramatic and impactful. Erase any structural elements and keep your lines smooth and clean.

5 Keep the colors warm and glowing. Fire should be the brightest thing you draw. Leave highlights for the hottest part of the flames, and outline the flames in red or orange instead of black. Outline his eyes in yellow instead of coloring them in. The white in the centers of the eyes makes them glow.

You Know You're Tough When...

Tough Villains should be impressive-looking characters based on relatively simple concepts. Ironer's metallic skin gleams as he leaps into battle. His wild, mane-like hair gives him a untamed look. A strangely expressive mask hides Turncoat's identity. This unpredictable character may help the heroes one day and betray them the next. Her motivations are unclear, but she is fast and deadly. Don't get on her bad side.

the *flying* Hero

One of the most basic yet awe-inspiring superpowers is flight. The sight of a colorful superhero soaring above the city is one of the most familiar images in comics. Flying heroes are necessary to save all the people who fall out of airplanes and tall buildings daily in the comic book universe.

1 Create a definite line of action as you sketch the basic form. Starlighter should look like she's rising up from the ground. Her pose is confident and strong.

2 Give her teen proportions and keep her body rounded and soft. Block in the feet and hands, plus a few details like hair, facial features and her wand.

3 Develop the details that were hinted at in step 2 and work on her costume. Sketch loosely and lightly so you can explore and erase extra lines later. A multitude of stars trail behind her when she flies.

Character Profile

Name: Starlighter

Origin: Her powers stem from the magical wand given to her by a mysterious wizard; it reputedly holds a piece of a magical meteor.

M.O.: She is a very inexperienced hero who works with Star Cat to battle a seemingly endless supply of evil monsters.

Powers: Along with the power of flight she can fire star beams at her opponents and protect herself with a force field of stars.

Weaknesses: If someone else gains possession of the wand, she loses her powers.

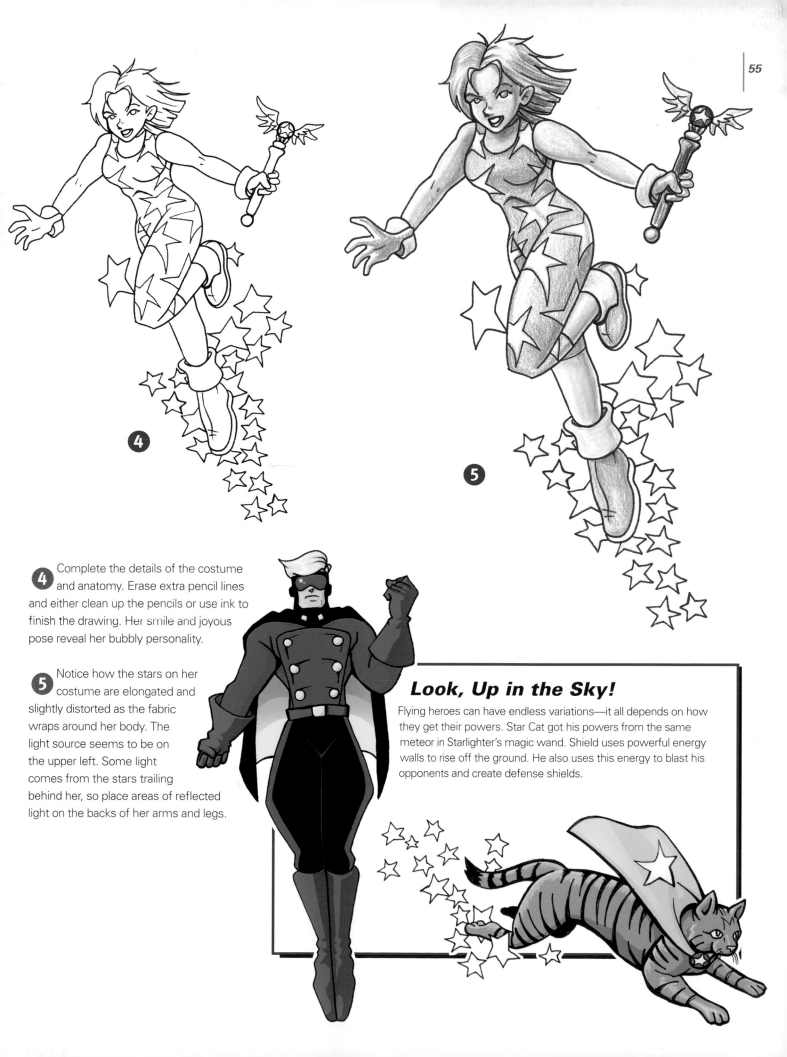

4 Complete the details of the costume and anatomy. Erase extra pencil lines and either clean up the pencils or use ink to finish the drawing. Her smile and joyous pose reveal her bubbly personality.

5 Notice how the stars on her costume are elongated and slightly distorted as the fabric wraps around her body. The light source seems to be on the upper left. Some light comes from the stars trailing behind her, so place areas of reflected light on the backs of her arms and legs.

Look, Up in the Sky!

Flying heroes can have endless variations—it all depends on how they get their powers. Star Cat got his powers from the same meteor in Starlighter's magic wand. Shield uses powerful energy walls to rise off the ground. He also uses this energy to blast his opponents and create defense shields.

the gadget Hero

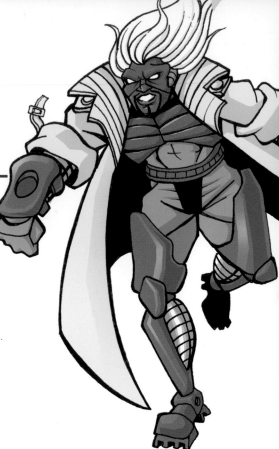

The Gadget Hero always has just what is needed to get out of a tricky situation. They may not have any special powers, but they can join the ranks of superheroes by using items that can be just as powerful. They may not be able to hurl bolts of energy from their fingertips, but they could build a device to do the job.

Their identities are usually more defined by their gadgets than the Detective Hero. Gadget Heroes might be funded by governments or huge corporations, or they may be backyard inventors. Or, they may have just stumbled across their gadget or received it as a gift to carry on the traditions of the superheroic identity.

1 The pose is powerful and extreme. The character is in combat mode running at full speed toward the viewer. Tilting the figure off-balance exaggerates the intensity of the action.

2 Block in the anatomy and equipment. He should have an impressive presence. His gear pops out of his armor, and extra equipment is bolted on for special missions.

Character Profile

Name: Azadim

Origin: Dismissed from a top-secret military project, Azadim built a collection of gadgets to continue his own research.

M.O.: A man of few words, he is a ruthless crimefighter, but refuses to carry weapons.

Powers: Azadim uses his gadgets to track criminals, swing from buildings and entangle his opponents. He has no superpowers.

Weaknesses: He is virtually powerless without his equipment and is growing tired of his life as a costumed crimefighter.

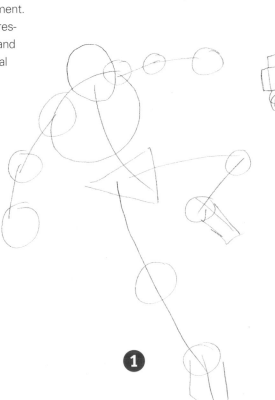

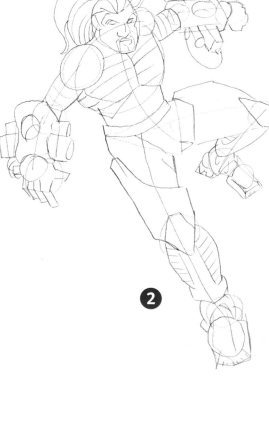

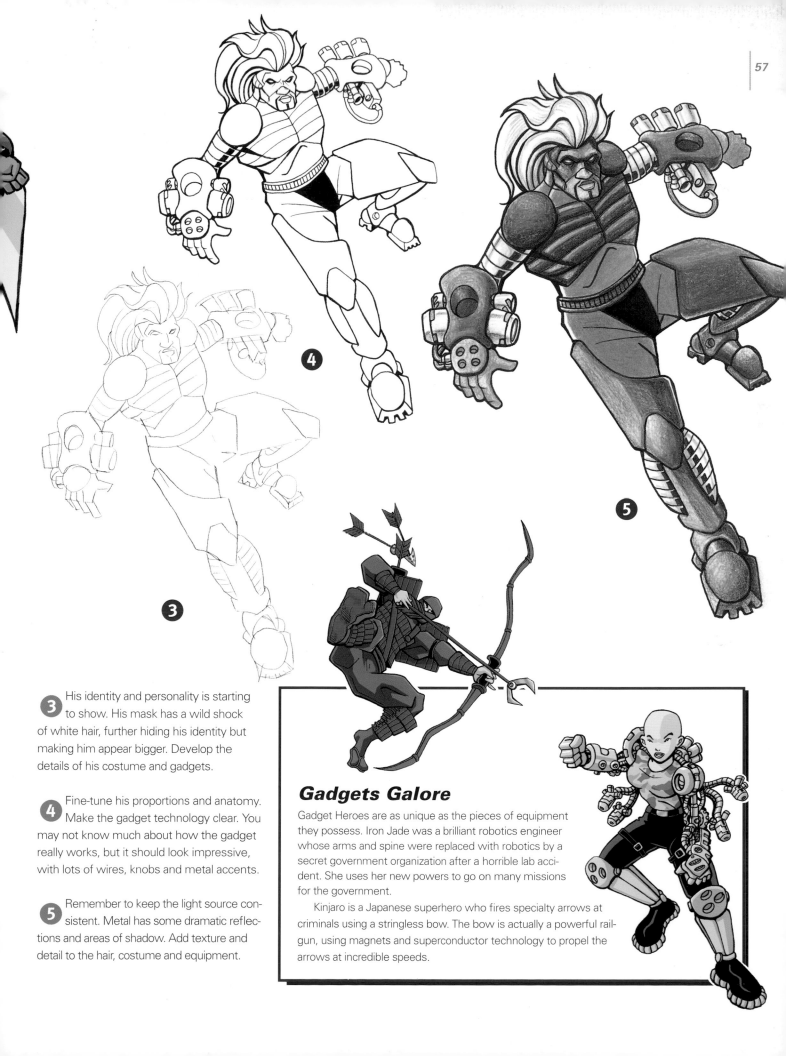

4

5

3

3 His identity and personality is starting to show. His mask has a wild shock of white hair, further hiding his identity but making him appear bigger. Develop the details of his costume and gadgets.

4 Fine-tune his proportions and anatomy. Make the gadget technology clear. You may not know much about how the gadget really works, but it should look impressive, with lots of wires, knobs and metal accents.

5 Remember to keep the light source consistent. Metal has some dramatic reflections and areas of shadow. Add texture and detail to the hair, costume and equipment.

Gadgets Galore

Gadget Heroes are as unique as the pieces of equipment they possess. Iron Jade was a brilliant robotics engineer whose arms and spine were replaced with robotics by a secret government organization after a horrible lab accident. She uses her new powers to go on many missions for the government.

Kinjaro is a Japanese superhero who fires specialty arrows at criminals using a stringless bow. The bow is actually a powerful rail-gun, using magnets and superconductor technology to propel the arrows at incredible speeds.

the *powered* Armor Hero

Powered Armor Heroes are a very specialized form of Gadget Hero. Their powers come from high-tech suits that they wear, which also hide their true identity. Underneath they are normal people. The armor doesn't need to be technological in nature. It could be magical armor, or even an organic life form that merges with the hero to create a new identity.

1 This pose is unusual in that the armored character is putting on her helmet as she launches into combat. Keep the action dynamic, but remember to start with the basics. Don't jump right into the details without planning the image.

2 Make the armor sleek and high-tech. Some influences from medieval armor and anime robots give it a unique, stylish design. As you block in the areas of armor, use feminine proportions and anatomy references to make her appear convincing.

Character Profile

Name: Windburn

Origin: Jessica Mathers worked tirelessly for the government to develop the Windburn armored suit.

M.O.: Flies in and bashes the bad guys with powerful blasts of wind and debris.

Powers: Very protective armored shell. Flight and blaster systems linked to elaborate windblast mechanism.

Weaknesses: The suit will run out of power after a few hours of intense use.

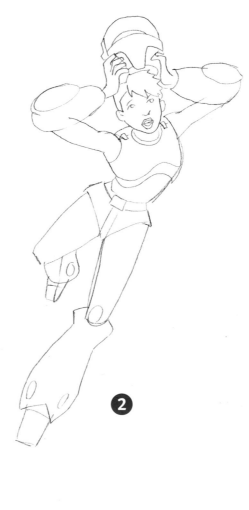

1

2

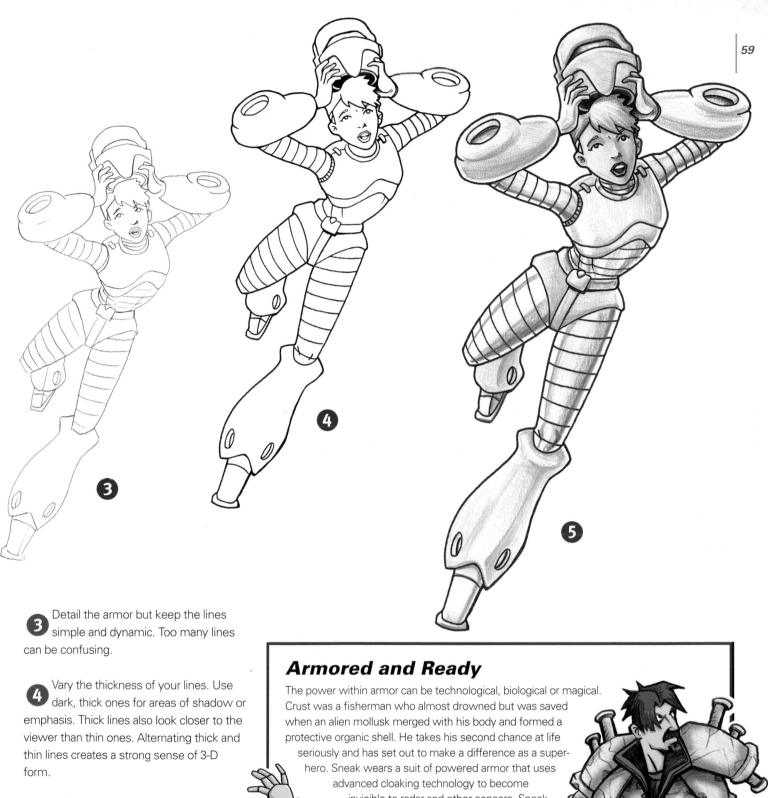

3 Detail the armor but keep the lines simple and dynamic. Too many lines can be confusing.

4 Vary the thickness of your lines. Use dark, thick ones for areas of shadow or emphasis. Thick lines also look closer to the viewer than thin ones. Alternating thick and thin lines creates a strong sense of 3-D form.

5 Watch how light reflects on metallic surfaces. Strong and bold differences of light and dark and reflected light are common on metal objects.

Armored and Ready

The power within armor can be technological, biological or magical. Crust was a fisherman who almost drowned but was saved when an alien mollusk merged with his body and formed a protective organic shell. He takes his second chance at life seriously and has set out to make a difference as a superhero. Sneak wears a suit of powered armor that uses advanced cloaking technology to become invisible to radar and other sensors. Sneak is a former colleague of Windburn's who stole his suit from his lab before it could be used for military purposes.

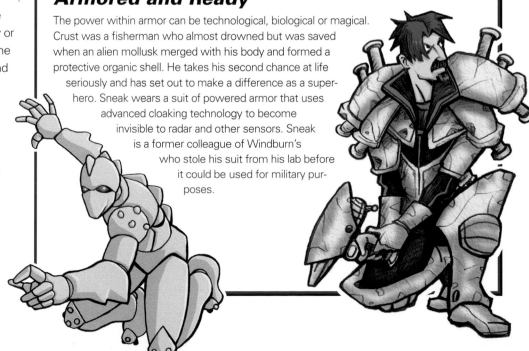

the Sidekick

The Sidekick is the second banana that follows the hero into battle against the forces of darkness. The writer usually uses this character as an opportunity for the hero to explain what is happening in the story. The Sidekick also provides convenient bait to lure the hero into a trap. The hero knows it will be a trap, but his sidekick must be rescued at any cost. The Sidekick can also temper the more vengeful vigilante tendencies of some heroes.

The Sidekick provides a bridge between the reader and the hero. Readers who are younger and less powerful than the hero can identify with The Sidekick living the dream of a junior superhero. Many former sidekicks graduate to become independent heroes who pursue their own adventures.

1 Block in this teen figure in action. Gargirl is small and willowy compared to most of the heroes and villains she encounters. Her feet are drawn larger than usual because of her big suction-cup boots.

2 Don't make her too muscular. She should be softer and more rounded than the standard hero. Note how her torso hides the arm on our right and how her forearm and hand are visible. Similar overlapping occurs with her raised leg. Details like this avoid the "flat" look.

Character Profile

Name: Gargirl

Origin: Became the sidekick of the vigilante hero Kimera after he saved her parents' lives from a suspicious fire.

M.O.: Moves quickly and uses homemade gadgets to fight crime.

Powers: No special powers, but relies on gadgets such as suction cups for climbing and clinging.

Weaknesses: Is often shocked and disappointed by Kimera's lack of respect for the law.

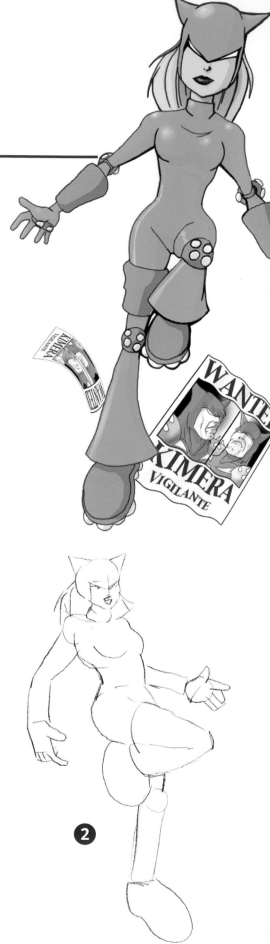

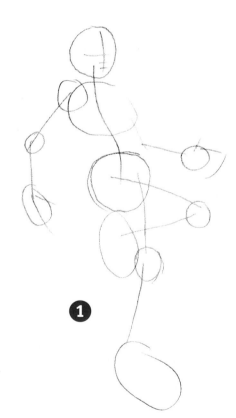

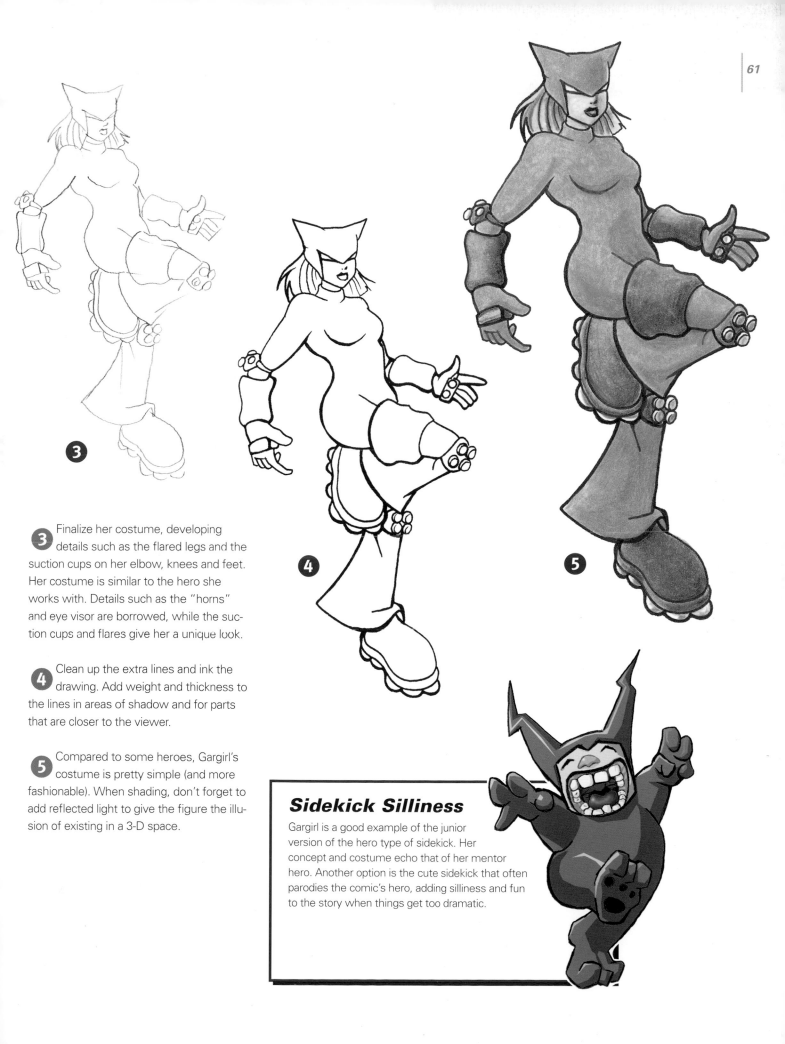

③ Finalize her costume, developing details such as the flared legs and the suction cups on her elbow, knees and feet. Her costume is similar to the hero she works with. Details such as the "horns" and eye visor are borrowed, while the suction cups and flares give her a unique look.

④ Clean up the extra lines and ink the drawing. Add weight and thickness to the lines in areas of shadow and for parts that are closer to the viewer.

⑤ Compared to some heroes, Gargirl's costume is pretty simple (and more fashionable). When shading, don't forget to add reflected light to give the figure the illusion of existing in a 3-D space.

Sidekick Silliness

Gargirl is a good example of the junior version of the hero type of sidekick. Her concept and costume echo that of her mentor hero. Another option is the cute sidekick that often parodies the comic's hero, adding silliness and fun to the story when things get too dramatic.

the *energy blaster* Hero

E nergy Blaster Heroes can focus vast amounts of power and launch it at their enemies. This energy can come from a wide variety of sources. The hero may be able to summon bio-electric energy from a mutated nervous system and fire it from his eyes or hands. Other heroes must rely on special objects such as wands, rings or other artifacts.

1 The pose is very dynamic and full of action. The blaster should be prominent in the pose, as it is the source of Pierce's powers.

2 Block in the muscles and some details. Keep the costume simple; it's just supposed to be a shell that wraps around his regular clothes. Even though you won't be seeing any facial features, it is still a good idea to block in where they would be.

Character Profile

Name: Pierce

Origin: David Stillson was a petty criminal looking to reform. One night an alien escape pod crashed on the highway; when he rushed to help he was given an unusual blaster from a dying alien.

M.O.: Stillson uses his shady contacts to gain information on criminal activity and then rushes in as Pierce to stop them.

Powers: The alien's gift acts as a force field and blaster. It also covers Stillson in an armored suit that hides his identity and protects him from the harsh conditions of space.

Weaknesses: The blaster is so attuned to Stillson that if it is taken away, it will just reappear in his hands. When it needs time to re-energize, however, he is left very vulnerable.

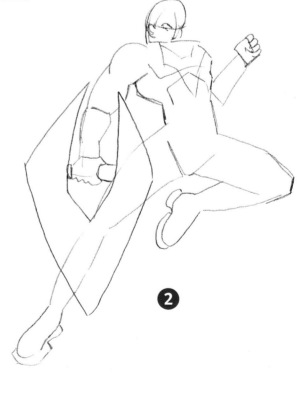

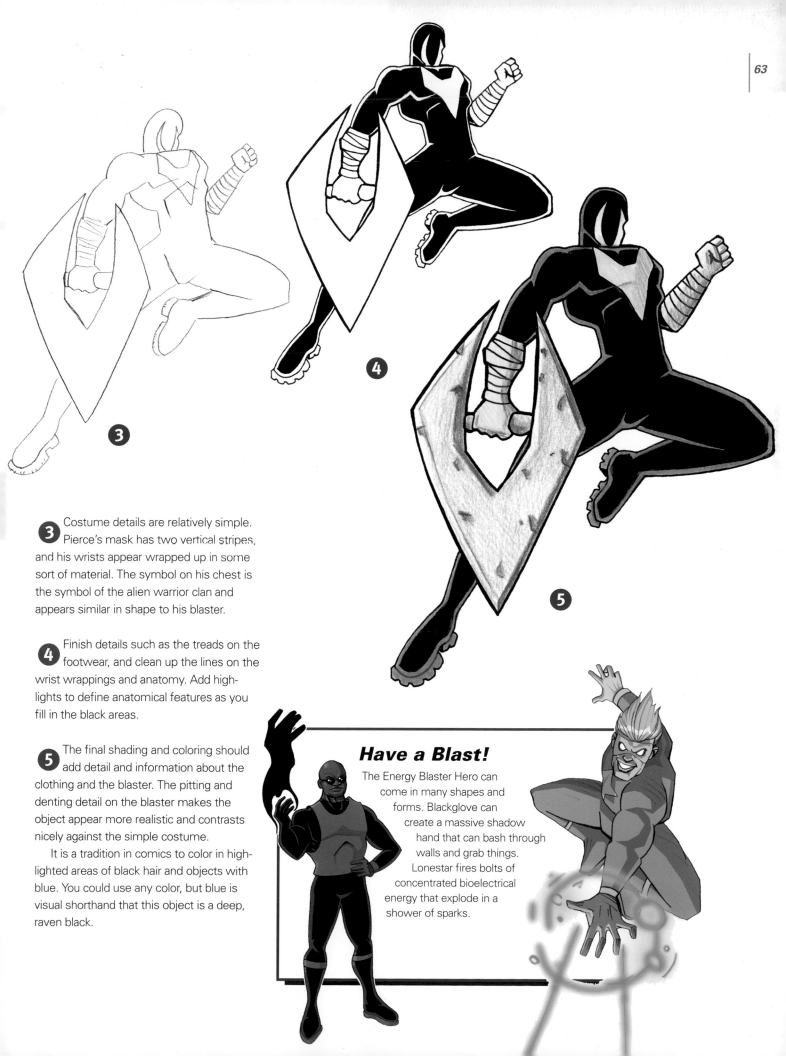

3 Costume details are relatively simple. Pierce's mask has two vertical stripes, and his wrists appear wrapped up in some sort of material. The symbol on his chest is the symbol of the alien warrior clan and appears similar in shape to his blaster.

4 Finish details such as the treads on the footwear, and clean up the lines on the wrist wrappings and anatomy. Add highlights to define anatomical features as you fill in the black areas.

5 The final shading and coloring should add detail and information about the clothing and the blaster. The pitting and denting detail on the blaster makes the object appear more realistic and contrasts nicely against the simple costume.

It is a tradition in comics to color in highlighted areas of black hair and objects with blue. You could use any color, but blue is visual shorthand that this object is a deep, raven black.

Have a Blast!

The Energy Blaster Hero can come in many shapes and forms. Blackglove can create a massive shadow hand that can bash through walls and grab things. Lonestar fires bolts of concentrated bioelectrical energy that explode in a shower of sparks.

the magic Master

*O*ne of the first classic superhero types was the mystical hero. Some were masters of magic; others had the ability to cloud the minds of men with amazing mental powers. Magic Masters provide endless stories where their magic gets out of control or produces effects they could have never imagined. How they cast their spells, either from massive spell books or by saying magic words, is part of the fun of creating the character.

1 Sorceress stands firm, ready to cast a spell. Her arms and hands should be in motion, as if she's weaving some sort of spell. Notice how she is twisting slightly and her head is slightly tilted down. She is still fairly young, so use teen proportions.

2 One arm covers part of her torso. Draw the covered part anyway so you can understand what's going on underneath. Lightly sketch some costume details. She's young, but her daemon blood makes her powerful. Her expression is confident.

Character Profile

Name: The Sorceress

Origin: Caught in the middle of a wizard war, the young Sorceress was blasted into the present day from the 12th century.

M.O.: Sorceress uses her magic in a flashy, forceful manner. She comes from a time when magic was more common.

Powers: All manner of magical spells and abilities.

Weaknesses: It was rumored that her father was the daemon lord Scortan— a past that could come back to haunt her.

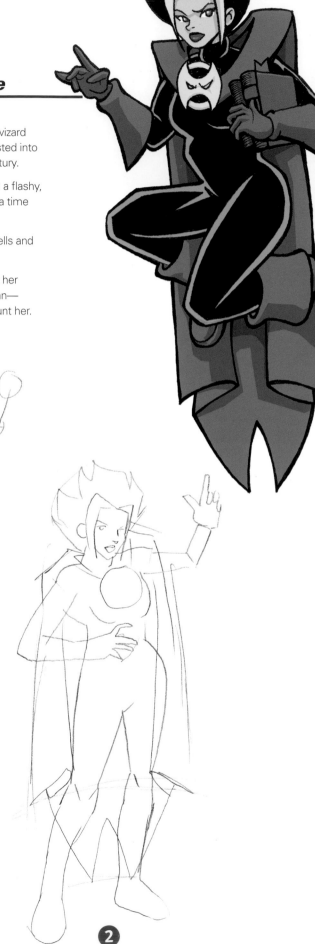

1

2

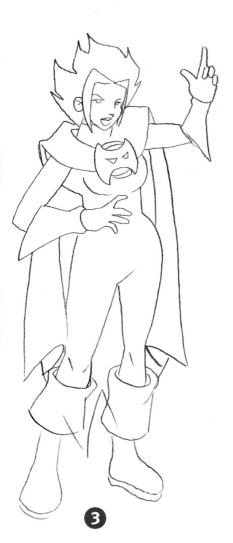

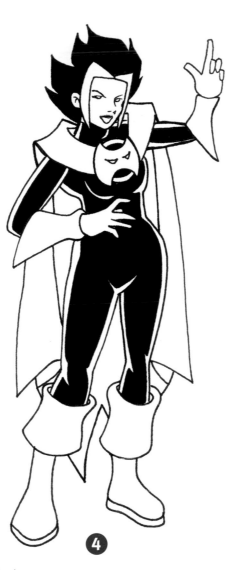

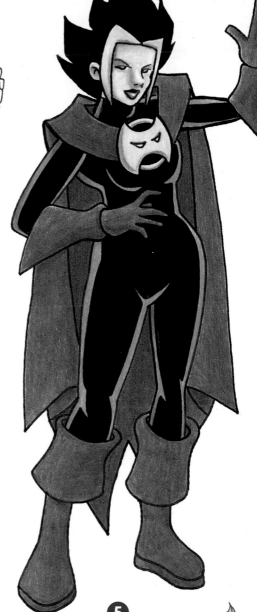

3 Clean up the details such as her spiked hair (tousled by many spells), her unique cape, gloves, boots and oversized brooch. The mask-like brooch is a symbol of her magical heritage. Her cape echoes the shapes found on her symbol.

4 As you ink the drawing, fill in the details such as the black bodysuit. When the ink dries, carefully erase the pencil lines. The highlights on the body ensure that the details of anatomy are not lost or flattened by coloring everything in black.

5 Purple lends a royal look. Her golden bangs and symbol stand out against the dark, cooler colors. Her eyes glow red, revealing a darker nature just under the surface.

Magic in Many Forms

Sorceress has a traditional comic book magician look, but there are many ways to show a Magic Master. The origins of the magic do not always have to come from medieval European sources. Guardian Spirit is a mysterious street person who protects the citizens of the city from evil spirits. Technomancer uses the complexity of electronics and machines to weave spells and control technology.

the **mythic** **Hero**

Mythic Heroes are based on legends and myth, but unlike Magic Masters, they don't necessarily use magic powers. Some resemble heroes like King Arthur or Hercules. Others are mythical creatures like satyr or pixies. Mythic Heroes were, of course, the first tales of superheroes.

1 The Hooded Man is a man of action, so his pose should be as dynamic as his reputation. The bow is indicated at this early stage because it is such a major part of the character's identity.

2 Block in more details, including the cape, hood, quiver of arrows and anatomical features. The boots will be classic "heroic" boots with big cuffs.

3 Clean up the details and add little touches like the fact that the boot cuffs do not hug the legs tightly and the finger is holding the arrow down. Develop the hair, beard and scale-mail shirt. Stagger the scales so they fall in an alternating pattern.

4 Clean up the lines. Don't overdo it with detail: A few lines on the arrow feathers are much more effective than trying to draw every line that you know is there. The same rule applies to drawing hair, whether it's the hair on his head or his beard.

5 Show the roundness of form on the boot cuffs and the cape. The earth tone colors support the medieval source of inspiration for this character. Shade using complementary (opposite) colors: reddish brown to darken the green cape and green to darken the reddish brown. This adds a richness to the color that using black would not do.

Character Profile

Name: The Hooded Man

Origin: The current incarnation of the "Robin Hood" character. He took over the identity of the hero from his father.

M.O.: He robs from the rich and gives to the poor, but he also fights injustice.

Powers: He has a magical bow and enchanted arrows. He may perform feats of supernatural acrobatics and strength when he is helping the downtrodden.

Weaknesses: He is considered to be an outlaw by some heroes.

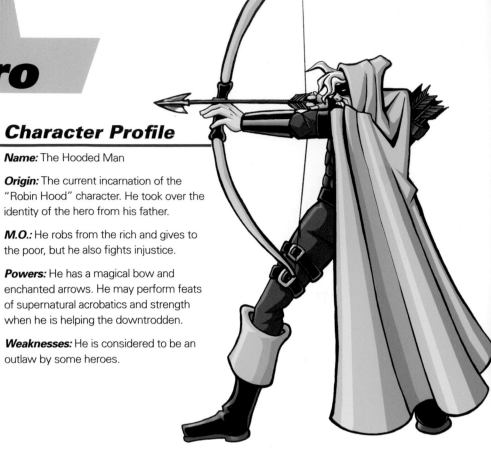

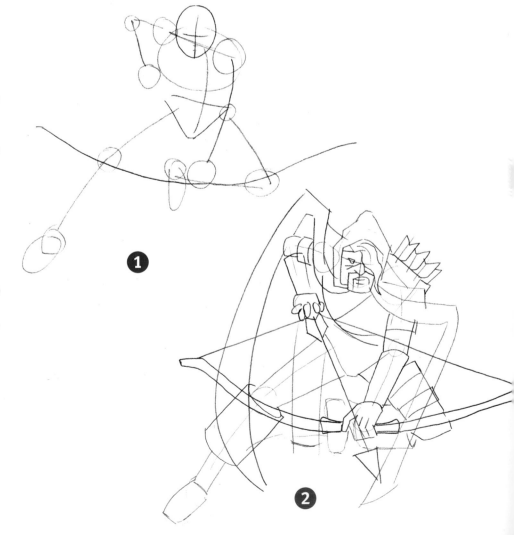

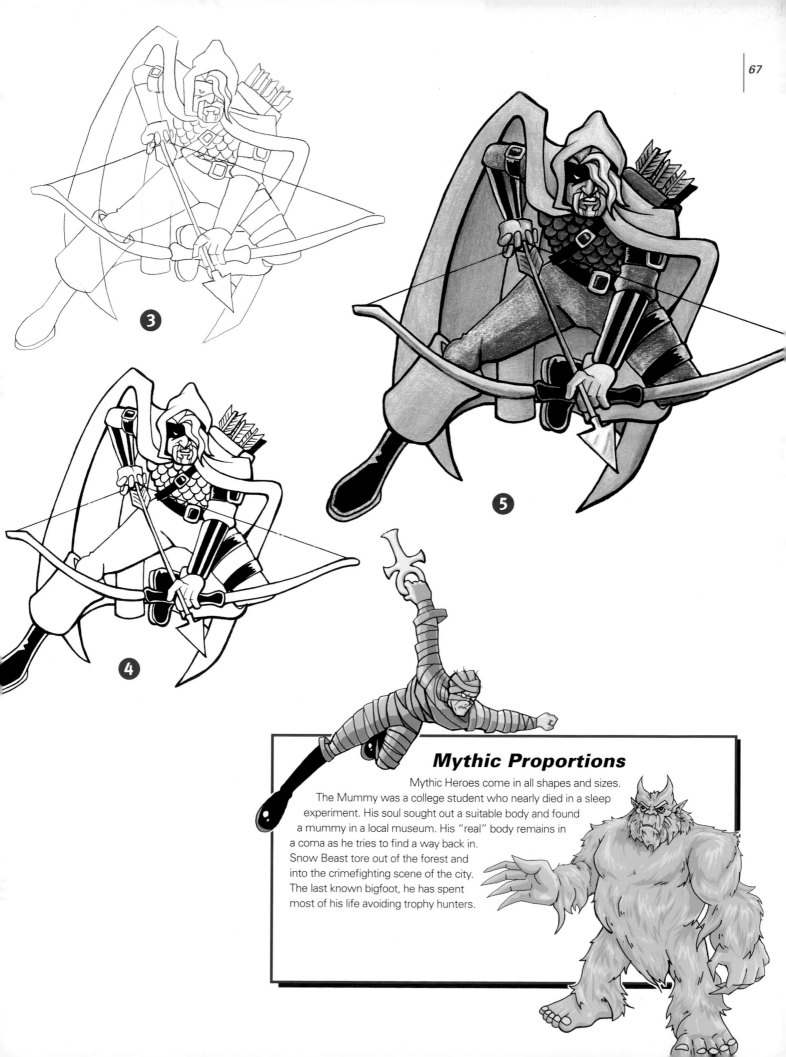

3

4

5

Mythic Proportions

Mythic Heroes come in all shapes and sizes. The Mummy was a college student who nearly died in a sleep experiment. His soul sought out a suitable body and found a mummy in a local museum. His "real" body remains in a coma as he tries to find a way back in. Snow Beast tore out of the forest and into the crimefighting scene of the city. The last known bigfoot, he has spent most of his life avoiding trophy hunters.

the *big* Tough Guy

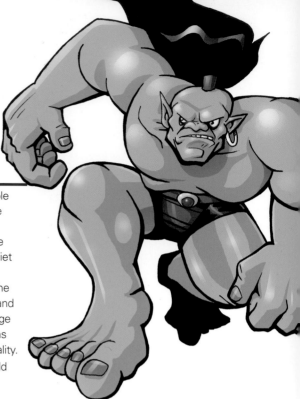

The Big Tough Guy towers over his teammates and can often level a building with a stomp of his foot. This villainous type represents the extremes of anatomy and raw strength with inhumanly exaggerated muscles and proportions. What could be more intimidating than a screaming wall of muscle tearing through the landscape, heading right for you?

1 His proportions are inhumanly exaggerated, but you should still start with the basic shapes to make him appear convincing. His head is small and his fists are huge. He is leaning forward in an all-out run.

2 Establish the details of the anatomy and the costume. Add some details of the ground to show the powerful effects of his stomping.

The Mighty Blue Genie

The Mighty Blue Genie is a good example of a superhero that takes on an alternate form while fighting crime. Payne Gray found a magic lamp in the antiques store he inherited from his uncle. Usually a quiet antiques dealer, he transforms into the Mighty Blue Genie every time he rubs the lamp. His body is sucked into the lamp and he gains the physical strength and strange powers of a youthful genie. He also gains elements of the genie's forceful personality.

The Mighty Blue Genie is big and bold and breaks everything he touches. He's popular and confident, everything that Payne Gray isn't. It's a classic Jekyll and Hyde act. He returns to his human form when he falls asleep or is knocked unconscious, and the Genie form returns to the lamp and awaits the next adventure.

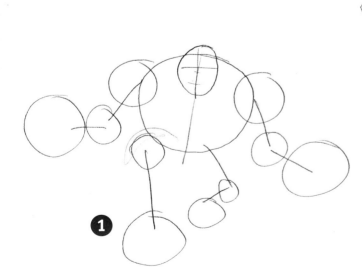

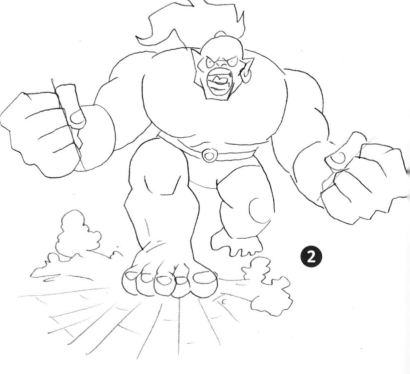

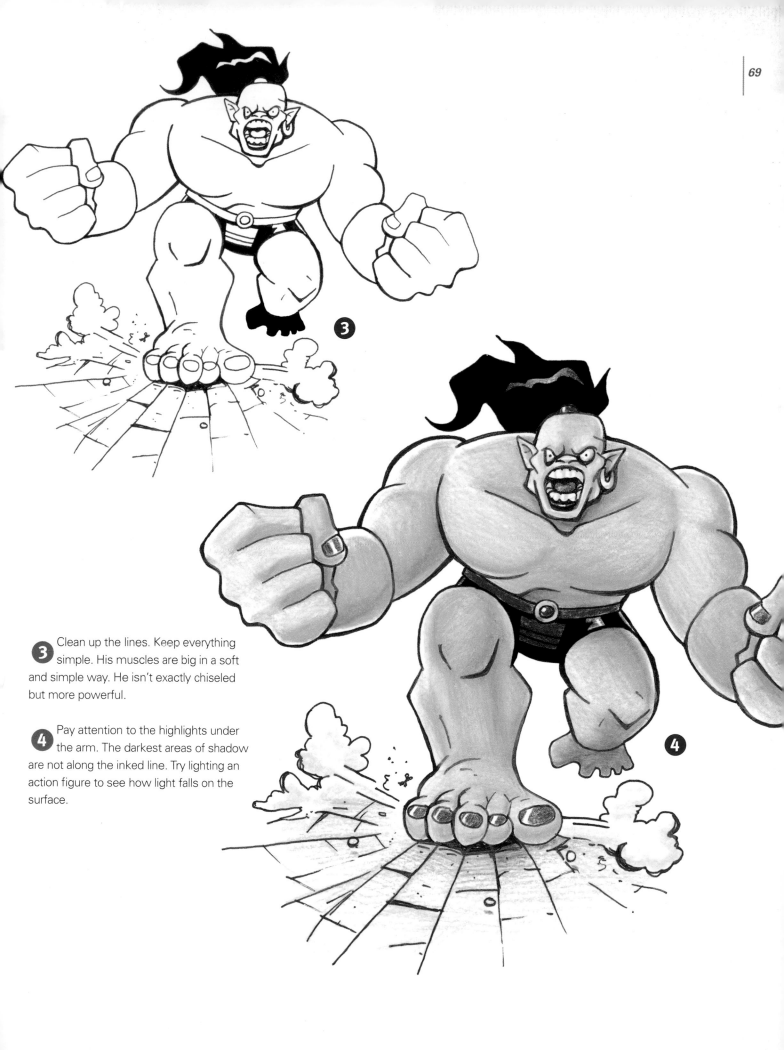

3 Clean up the lines. Keep everything simple. His muscles are big in a soft and simple way. He isn't exactly chiseled but more powerful.

4 Pay attention to the highlights under the arm. The darkest areas of shadow are not along the inked line. Try lighting an action figure to see how light falls on the surface.

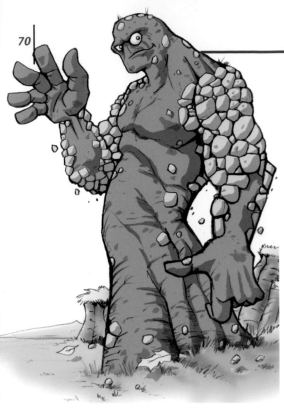

The Groundskeeper

The Groundskeeper is an elemental creature who has joined humanity to fight the forces of evil. He can meld with the earth and travel anywhere on the globe. He has no alternate form. His monstrous appearance is difficult to conceal and fearsome to behold.

The Groundskeeper represents the extremes that superhero anatomy can reach. Even though the figure is not realistic, try to make it look logical and convincing. Readers will have a harder time suspending their disbelief if the character looks cartoonish or poorly proportioned.

1 Try to capture the weight and movement of the figure as you draw the basic forms. The proportions will be exaggerated and specific to this character.

2 Begin blocking in the details and exaggerate the differences between this character's proportions and the standard human figure. Every part of the character deviates from the norm.

3 Vary the line thickness to show form and weight. Details such as the grass, roots and falling pebbles add to the believability of the image. Color the image carefully to show the form of the figure. Rendering each stone with shadows, highlights and reflections is a lot of work but well worth the effort.

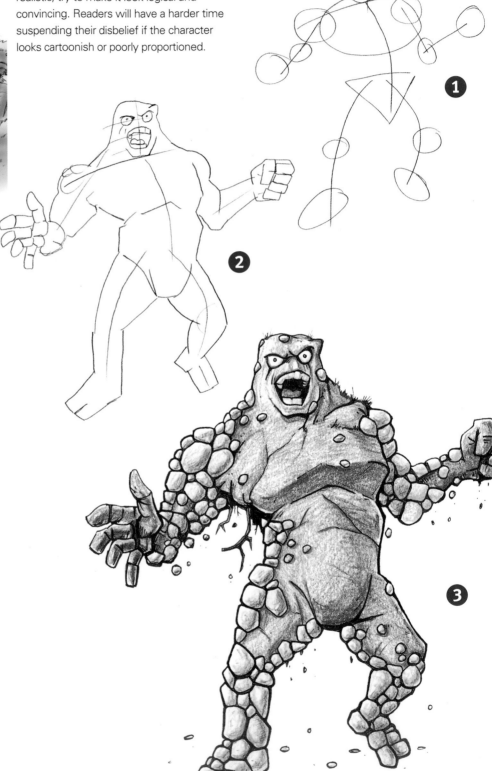

the Speedster

Speedsters are the fastest things on the face of the Earth. Many are able to circle the globe in minutes, running so fast that they can move across water or up walls.

1 This pose is a good example of extreme foreshortening. His arms are raised, slowing him down from his super-speed run. He is crouched to reduce the drag of wind on his body.

2 The costume is very simple, but that means that the anatomical details such as the leg and arm muscles must be drawn very accurately. Keep him muscular but lean. If he's too big it will be hard to believe he could move that fast.

3 Erase the remaining guidelines or trace the figure onto a clean sheet of paper. When you ink the figure, filling in large areas of black, be careful not to ink over the highlights. His costume is simple: understated black with red highlights.

Hype

Hype was very young when his powers started to develop. He trained for many years with a government-sponsored team of teen heroes. In this team setting he developed a strong sense of using his powers in a constructive way.

Hype is a lean, mean running machine. He takes his role as a hero very seriously, training as if he were an Olympic athlete. Hype hopes to become a major superhero with worldwide influence. Raised with his powers openly displayed, he has felt no need to hide his identity.

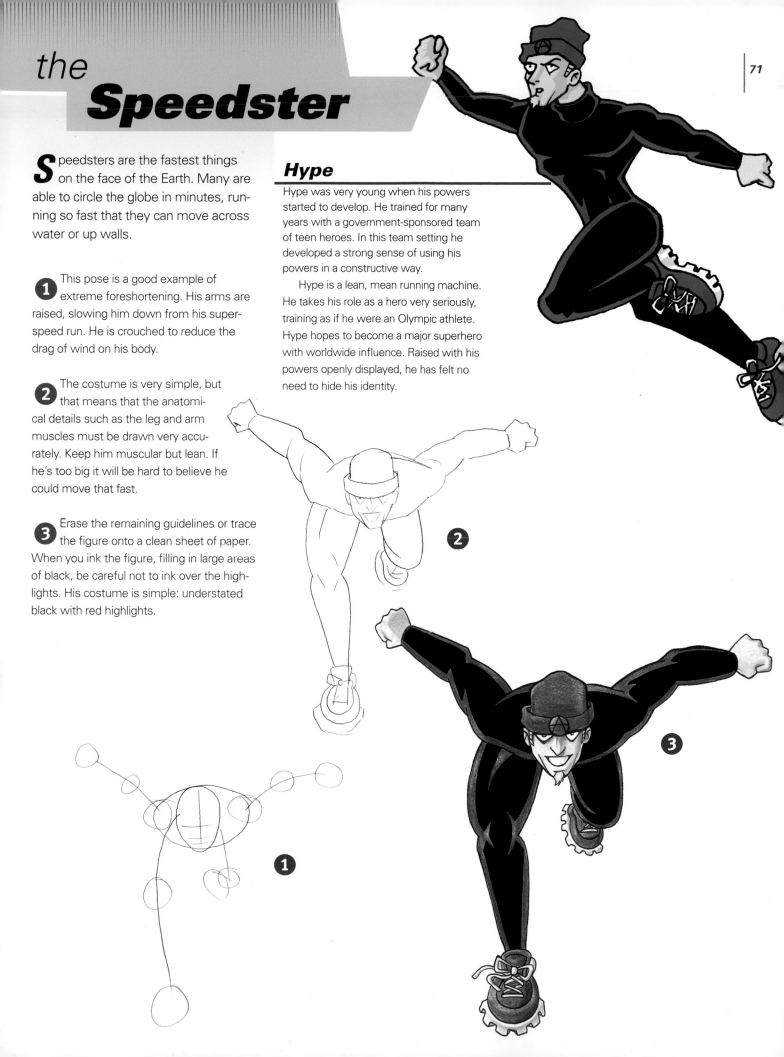

the *secret identity* Hero

Superheroes make a lot of very powerful enemies. Most heroes can take care of themselves, but their friends and loved ones can't. Why hide your identity? Because keeping your identity secret keeps your "normal" life normal. Villains are a cowardly, vengeful lot and would love to use someone special to the hero as food for a man-eating plant or bait for an elaborate trap.

Book Smart

Mild-mannered librarian Wanda Tome found a mysterious amulet hidden in a false book. When she wears it her body is suddenly wrapped in a magical costume that grants her the powers of the last book she read. Now Book Smart keeps the streets safe from riffraff. Unfortunately for her, she was reading a cookbook just before Sir Skull showed up. Omelets, anyone?

1 This dramatic pose will show the figure's transformation from Wanda to Book Smart. Keep your lines simple and easy to follow. Don't worry about the costume lines yet; just figure out where the amulet will be (swinging out from her neck).

2 Flesh out the details of the anatomy (including her upswept hair) and block in the lines for her costume, which seems to come together from ribbons that shoot from the amulet.

3 You can see how her costume goes right over her street clothes and even provides her with a handy mask to hide her identity. I chose fairly neutral colors for her street clothes. This makes her costume seem even flashier. Nobody would suspect this gentle soul of being a part-time crimefighter.

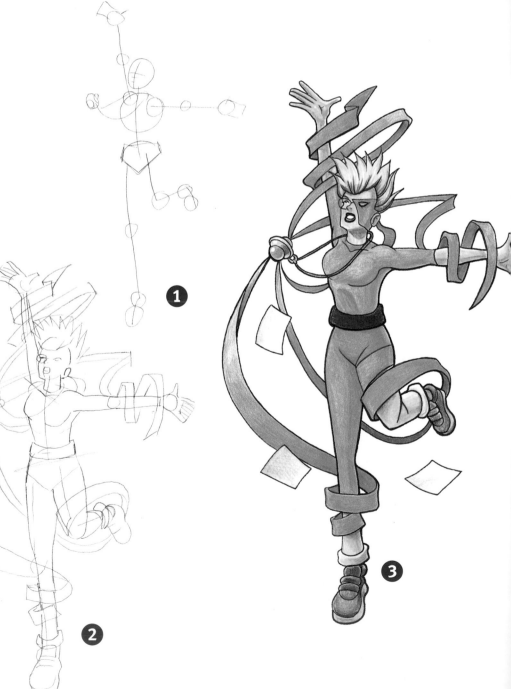

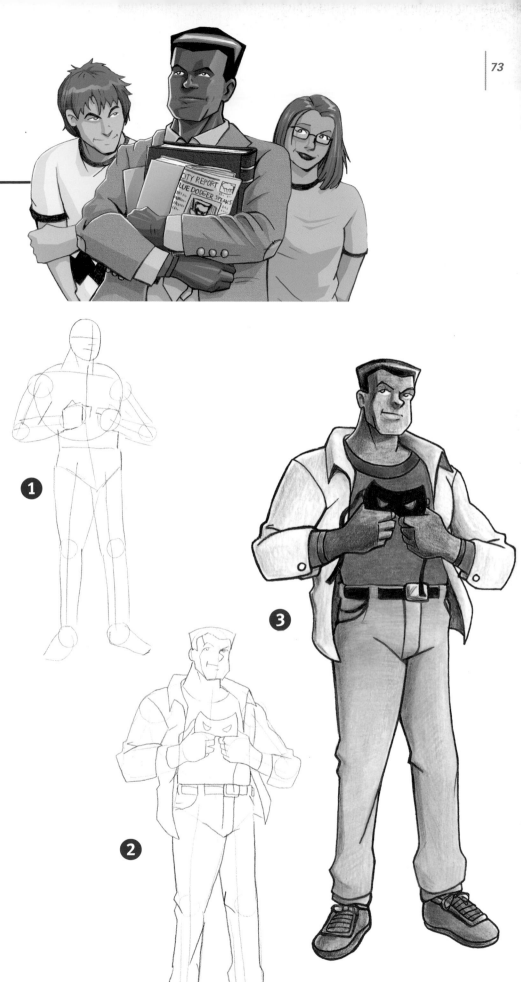

Blue Dodger

Popular high school teacher and amateur boxer Taylor Washington, frustrated by the injustices around him, created an alter ego to solve mysteries and fight crime. The costume was originally worn for the masquerade dance he was chaperoning. No one recognized him as he stopped an attack of robot cheerleaders. Named by the press for his impressive ability to get out of the way, Blue Dodger has no known superpowers but is a top athlete and tactical thinker.

Two students, Chip and Urchin, discovered his identity but kept it secret. They only asked that they be allowed to help his struggle, providing computer savvy and street smarts for the hero. Now Blue Dodger would be lost without them. Together, they solve mysteries, fight crime and learn a thing or two about life.

1 The pose is simple but should be strong even at this stage. He should appear powerful but not superhuman.

2 Add clothing and anatomy details. It's a good idea to keep a stack of old catalogs handy for reference when drawing clothing like button-down shirts.

3 Be careful to accurately draw the wrinkles on his shirt sleeves and pants. His mask and costume are simple, homemade items. Blue Dodger's costume is predictably blue, with red and black accents. Using brown hatching over yellow gives his pants a soft texture. He looks confident and proud, a real hero ready to take on the forces of darkness.

the Teen Hero

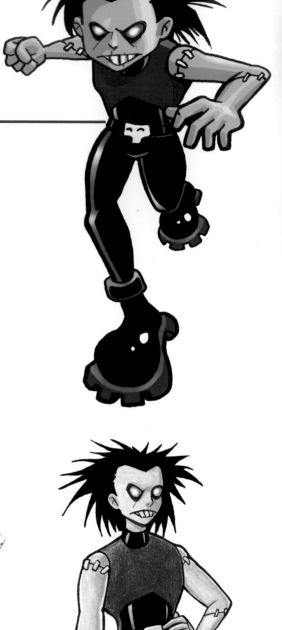

The Teen Hero is a staple in classic comics. Entire comics are devoted to teen heroes. More than just sidekicks, they have set out on their own. Teen Hero stories are characterized by angst-ridden soul searching, betrayal, goofiness, pimples, awkward infatuation and strange powers that make the hero feel alienated.

1 Use teen proportions as a guide for the anatomy. Zombie Boy likes to take in his surroundings before he acts. He's always ready to shamble into action.

2 Flesh out the figure with anatomy and costume details. A wild hairstyle and stitches on his body are defining elements of Zombie Boy.

3 Complete the linework and erase the guidelines. Carefully shade in the costume with black, being careful not to flatten it by making it all black. The highlights on the costume details add a more realistic, fully formed look. His skin should be a pale, greenish blue—he's a zombie, after all. The shadows on his face should be greatly exaggerated by his undead nature.

Zombie Boy

You might think Joey was like any other teenager, but you'd be dead wrong. Joey is a zombie, but his biggest worry is if he'll pass biology. Joey's "condition" developed after he fell into a vat of mysterious chemicals. Quiet and thoughtful, Joey just wants to be like everyone else, but then a monster shows up and it's up to Joey to save the day.

Zombie Boy brings together two things that helped define comics in the early years: horror and teen angst. Despite his frightening appearance and dark back story, Zombie Boy should be presented as an earnest teen who just wants to fit in, though he knows he never will.

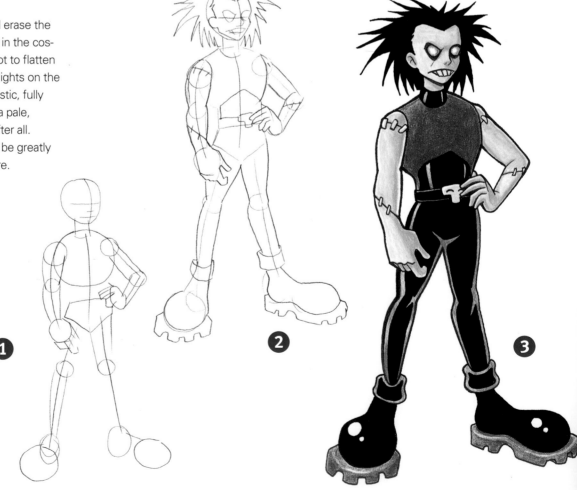

Red Ribbon

Red Ribbon's powers come from her magical costume that can fire a powerful ribbon of indestructible material to strike her foes, tie up the bad guys or swing from rooftop to rooftop. Her costume was found in a trunk that used to belong to her great-grandfather, an old-time magician. Red Ribbon's hobby is fighting crime, and she has a great time doing it. She isn't overly silly or goofy; she tends to have a more of a sarcastic and cynical view of things.

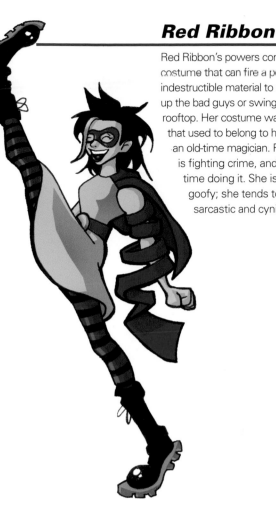

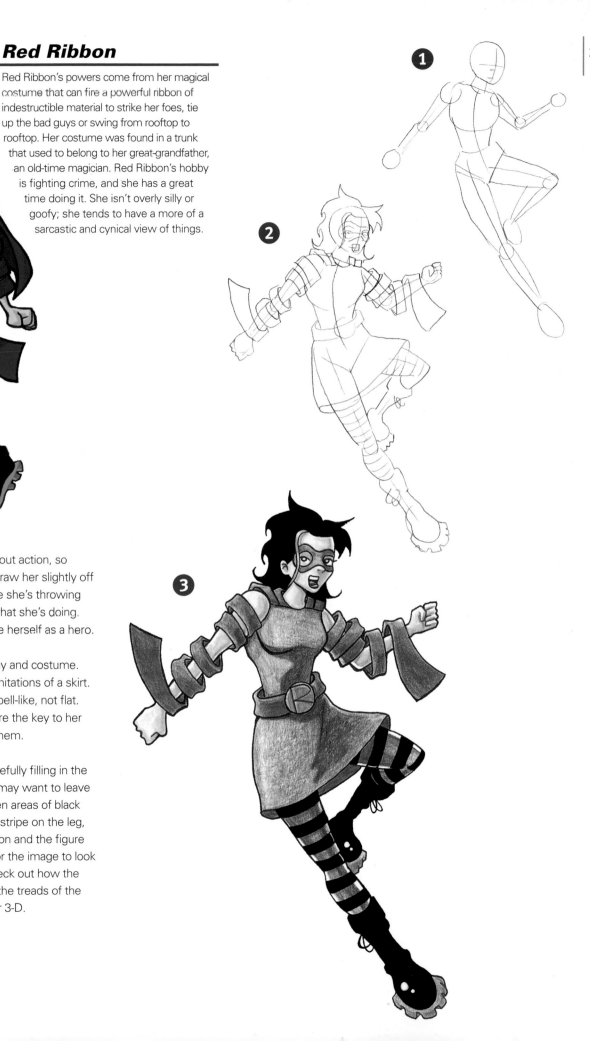

1 Red Ribbon is all about action, so keep her moving. Draw her slightly off balance; it should look like she's throwing herself completely into what she's doing. She is very eager to prove herself as a hero.

2 Block in the anatomy and costume. Keep in mind the limitations of a skirt. The skirt hem should be bell-like, not flat. The ribbons on her arm are the key to her powers, so don't forget them.

3 Ink the drawing, carefully filling in the areas of black. You may want to leave a small white line between areas of black such as the boot and the stripe on the leg, just so there's no confusion and the figure doesn't look too flat. Color the image to look rounded and realistic. Check out how the curve of the ribbons and the treads of the boots are made to appear 3-D.

Thugs

*T*hugs are essential in superhero stories. They let the heroes relate to real-world threats, showing off just how powerful they are. Thugs also help slow down the heroes just long enough to let the villains escape.

1 Make the goon's proportions large and impressive. Keep the shapes loose when you block out the form. His arms and legs should be powerful. His fists are huge!

2 Erase the under-drawing and add anatomy and costume details. This goon is a fairly small-time crook, but he still looks mean.

3 Keep the lines clean and solid. Details like the bandage on his nose and the tears in the shirt make him look even rougher around the edges. Keep your light source consistent as you shade the figure. Leaving some areas white gives a harsher highlight and makes the light look brighter. Don't forget about reflected light on the shadow side to give the figure a more convincing 3-D feel. Keep the colors simple.

The Goon

The Goon may not be the sharpest tool in the shed, but he gets the job done. He may be only human, but he can still give a superhero a rough time.

Be ready to draw your goon with all kinds of expressions and attitudes. Just think of the look on his face when his strongest punch has no effect on the Ultimate Hero.

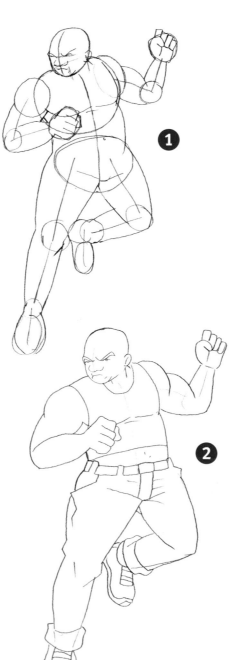

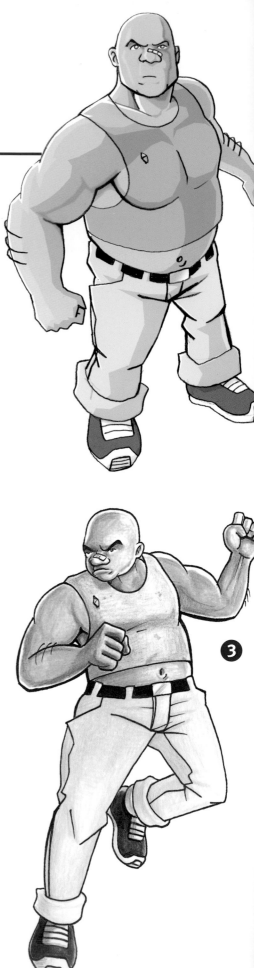

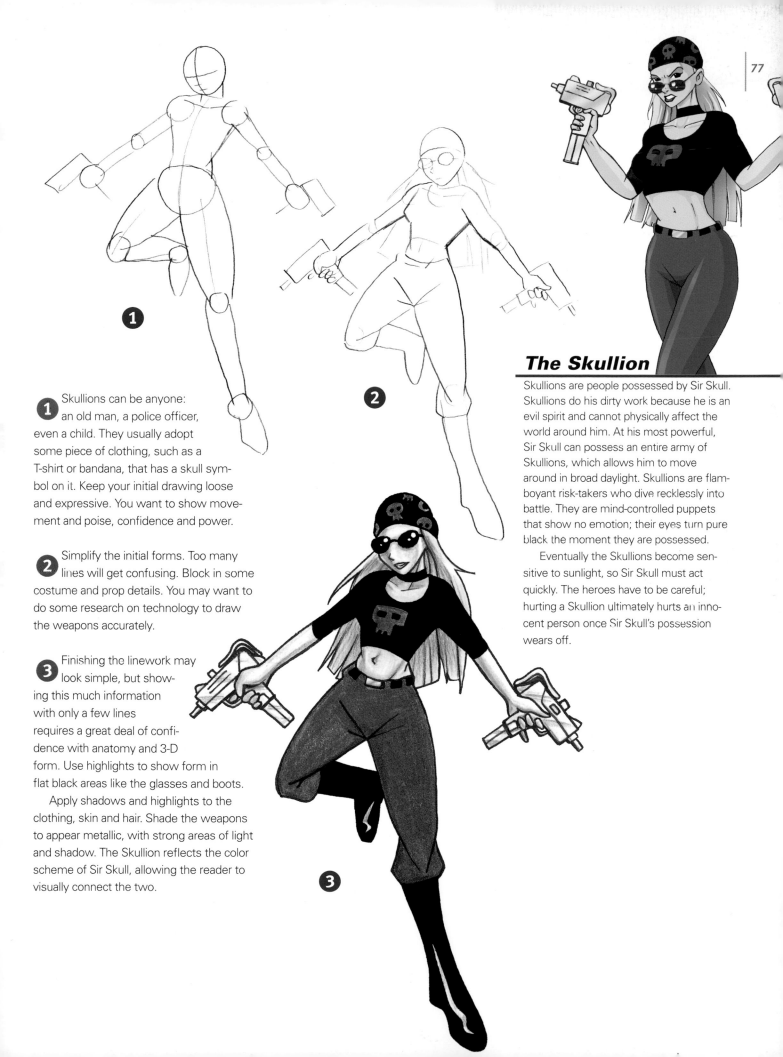

1 Skullions can be anyone: an old man, a police officer, even a child. They usually adopt some piece of clothing, such as a T-shirt or bandana, that has a skull symbol on it. Keep your initial drawing loose and expressive. You want to show movement and poise, confidence and power.

2 Simplify the initial forms. Too many lines will get confusing. Block in some costume and prop details. You may want to do some research on technology to draw the weapons accurately.

3 Finishing the linework may look simple, but showing this much information with only a few lines requires a great deal of confidence with anatomy and 3-D form. Use highlights to show form in flat black areas like the glasses and boots.

Apply shadows and highlights to the clothing, skin and hair. Shade the weapons to appear metallic, with strong areas of light and shadow. The Skullion reflects the color scheme of Sir Skull, allowing the reader to visually connect the two.

The Skullion

Skullions are people possessed by Sir Skull. Skullions do his dirty work because he is an evil spirit and cannot physically affect the world around him. At his most powerful, Sir Skull can possess an entire army of Skullions, which allows him to move around in broad daylight. Skullions are flamboyant risk-takers who dive recklessly into battle. They are mind-controlled puppets that show no emotion; their eyes turn pure black the moment they are possessed.

Eventually the Skullions become sensitive to sunlight, so Sir Skull must act quickly. The heroes have to be careful; hurting a Skullion ultimately hurts an innocent person once Sir Skull's possession wears off.

Acrobats

Acrobats use flips and jumps as a martial art. They can scale the sides of buildings and keep up with flying characters by leaping from building to building. They also have an impressive ability to get out of the way very, very quickly.

1 Panther's movements should appear fluid and graceful. Like his namesake, he should be powerful, yet sleek. Make him muscular, but avoid distorting the proportions to show his strength. His weight may be resting on his hand, but you can see how his legs are going to need to support that weight when he comes out of his cartwheel.

2 Erase the guidelines and keep the lines that create the form of the character. Panther's very distinctive claws need to look large and dangerous.

3 When you are drawing black clothing, draw the highlights on the figure to help define the surface anatomy and make the figure look less flat. The costume is a form-fitting leotard with built-in feet. The small domino mask should match the costume and may indicate that Panther needs to protect a secret identity.

The highlights are colored magenta. There are special areas in the highlights that are themselves highlighted. This reinforces the 3-D quality of the figure.

Panther

Panther is very quick and agile, with razor-sharp claws and a wit to match. He is wild, in more ways than one. His fingers grow into deadly claws that he uses with the ferocious intensity of a wild cat. He's also just a little crazy, which keeps both his enemies and his teammates guessing.

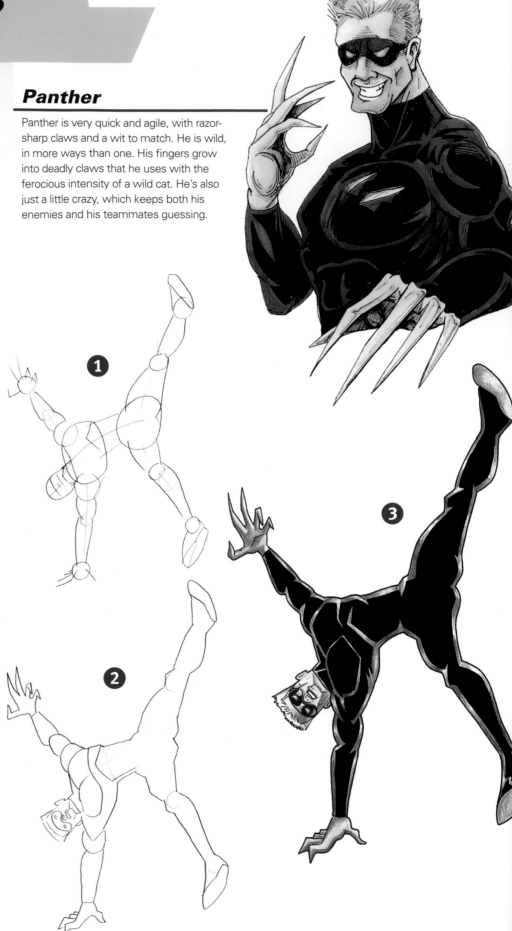

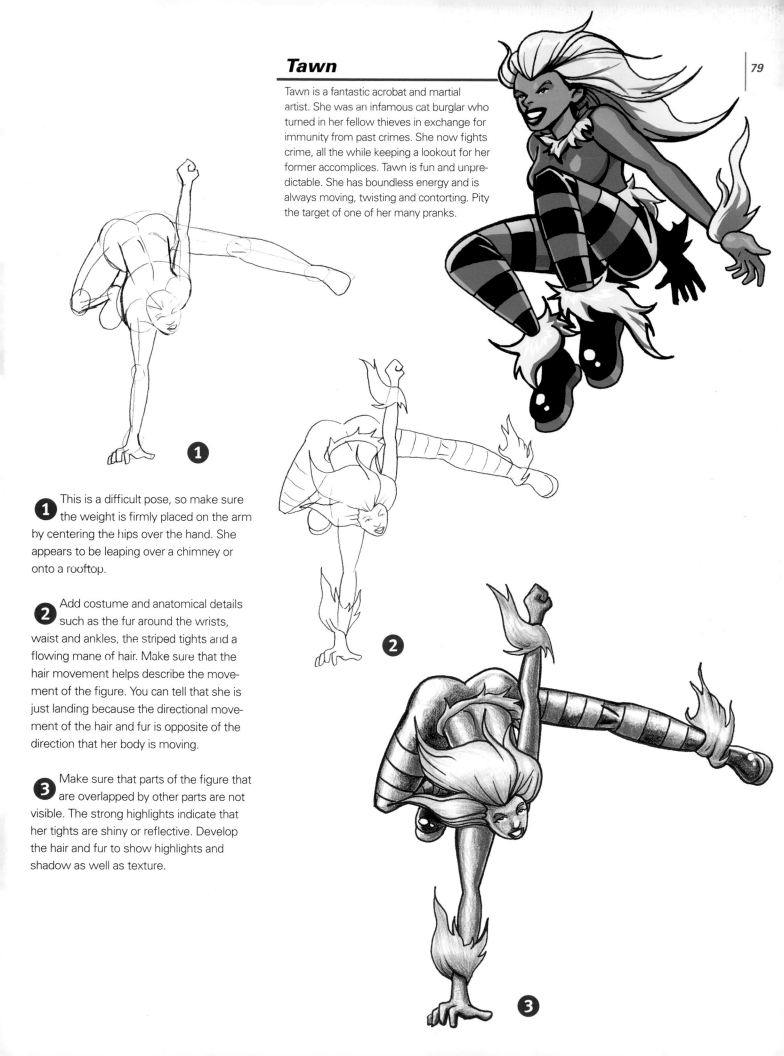

Tawn

Tawn is a fantastic acrobat and martial artist. She was an infamous cat burglar who turned in her fellow thieves in exchange for immunity from past crimes. She now fights crime, all the while keeping a lookout for her former accomplices. Tawn is fun and unpredictable. She has boundless energy and is always moving, twisting and contorting. Pity the target of one of her many pranks.

1 This is a difficult pose, so make sure the weight is firmly placed on the arm by centering the hips over the hand. She appears to be leaping over a chimney or onto a rooftop.

2 Add costume and anatomical details such as the fur around the wrists, waist and ankles, the striped tights and a flowing mane of hair. Make sure that the hair movement helps describe the movement of the figure. You can tell that she is just landing because the directional movement of the hair and fur is opposite of the direction that her body is moving.

3 Make sure that parts of the figure that are overlapped by other parts are not visible. The strong highlights indicate that her tights are shiny or reflective. Develop the hair and fur to show highlights and shadow as well as texture.

martial Artists

Comics are filled with traditional martial artists. Many comic heroes started out as simple brawlers, but today most are experts in a wide variety of martial arts from kung fu to ninjitsu. It is a good idea to identify the martial arts style used by the character, research that style's moves and basic stances, and then work hard to make the character's movements true to that style. Little details like this add an air of authenticity to your creation.

Tatsu

Tatsu is a Buddhist monk, trained in Shaolin kung fu, who fled to Japan after a run-in with dragon hunters in China. Linked to the spirit of the dragon tattooed on his chest, Tatsu can transform into a powerful dragon, but he loses his humanity a little more with each transformation. He fears the day when he is trapped in his dragon form forever. Tatsu's transformed dragon-self is truly an impressive opponent, attacking with blasts of flame and razor-sharp claws.

1 Express the strength and skill of the character in one powerful pose. Refer to real martial arts poses and stances for ideas.

2 Add costume and anatomical features carefully. Consider the effect of movement and gravity on the clothing and how it hangs off the figure. The front of the shirt is kept open to reveal the dragon tattoo.

3 Clean up the basic structure and make the clothing appear more 3-D. Make sure the details of the costume and tattoo are totally correct before you begin coloring. The orange robes identify this character as a monk from the Shaolin temple in China. The monks are well known for their martial arts abilities and their spiritual devotion.

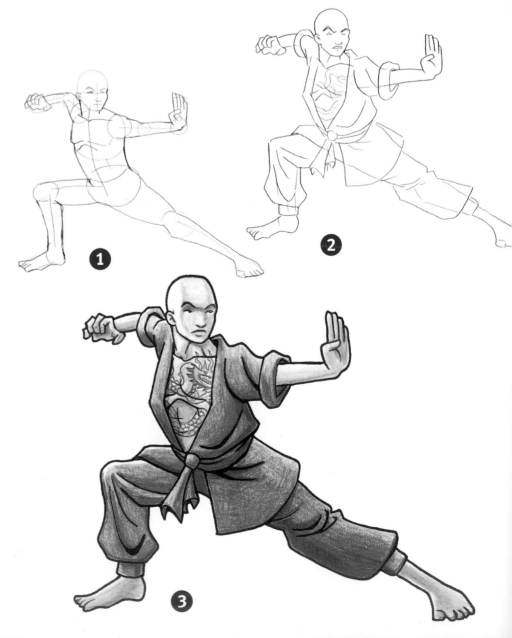

Agent Feng

Agent Feng is a secret agent who can ride the winds to perform fantastic feats of martial arts magic. She can run up walls and even appear to fly. The sole survivor of a secret society of demon hunters, she now battles the forces of evil in the dark underbelly of the city.

Agent Feng's wind-riding has saved her from destruction on many occasions. Feng is Cantonese for "wind." Outside she can generate winds powerful enough to lift a semi-truck and still control it with finesse.

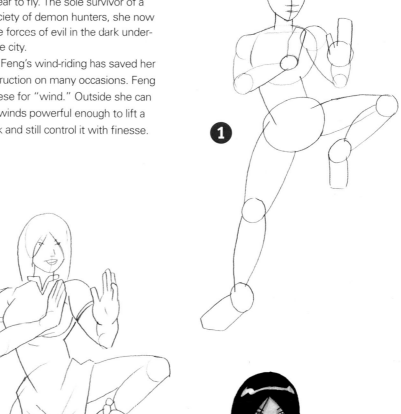

1 Keep your initial drawing loose and fluid. Concentrate on creating a convincing pose. Her hands are raised in a defensive posture and the leg is poised to execute a front kick.

2 Develop her anatomical and costume details, being very careful to depict the foreshortening of the arm on our right. Agent Feng's clothing is based on the design of a Chinese dress.

3 Clean up the lines and add details to the face, fingers and shoes. As you color and shade, don't forget about the shadow of the arm across the chest. Agent Feng looks ready to kick some demons.

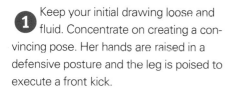

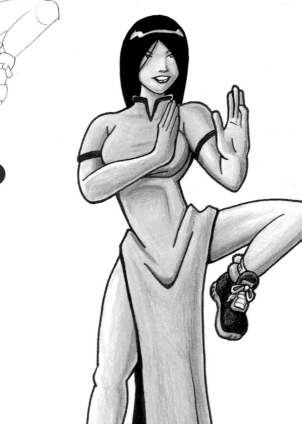

alien Invaders

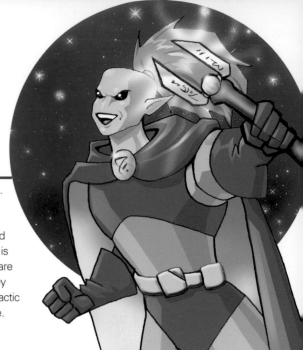

Not all strange visitors from other worlds are friendly. Some of them are downright hostile. It's a big, bad, beautiful universe out there, and it's up to Earth's heroes to save the day!

1 Even though the alien is not human, you still need to establish the basics of its anatomy. Here the lines, ovals and circles create the basic stance and give you much more anatomical information than you will really need for the final image.

2 The costume plays a big role in the way this character looks, so block it in now. He should look mysterious, yet powerful. The less human he looks, the more important it will be to develop a good model sheet so you can remain consistent when drawing him over and over again.

3 The costume is simple and futuristic. The wand he is holding seems to be a catchall technological device that can do anything from scanning a human to blasting a hole in the wall. Purples and greens have traditionally been associated with aliens in comic books. The strange writing on the costume reflects the alien's language.

The Alien Leader

The Alien Leader is insect-like and well… alien. It's hard for readers to relate to something totally alien, so some human qualities will make it easier to identify and respond to emotions and motivations. It is important to understand why the aliens are invading. Are they just exploring? Do they seek power? Is Earth in the way of a galactic superhighway? Know why they are here.

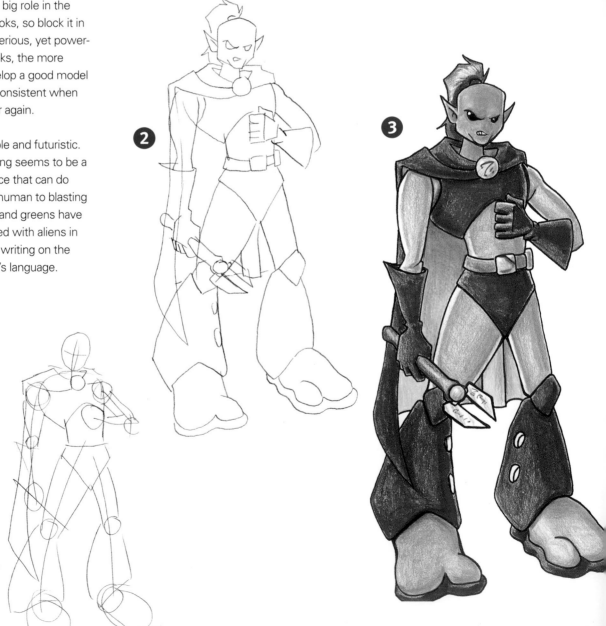

The Alien Warrior

The Alien Warrior does the Alien Leader's dirty work. They can be the nameless, faceless drones that the heroes cut down in droves, or they can be trained warriors who give the heroes a real battle for control of the Earth. The Alien Warrior often uses a combination of special alien abilities and technology far beyond the imaginations of human beings.

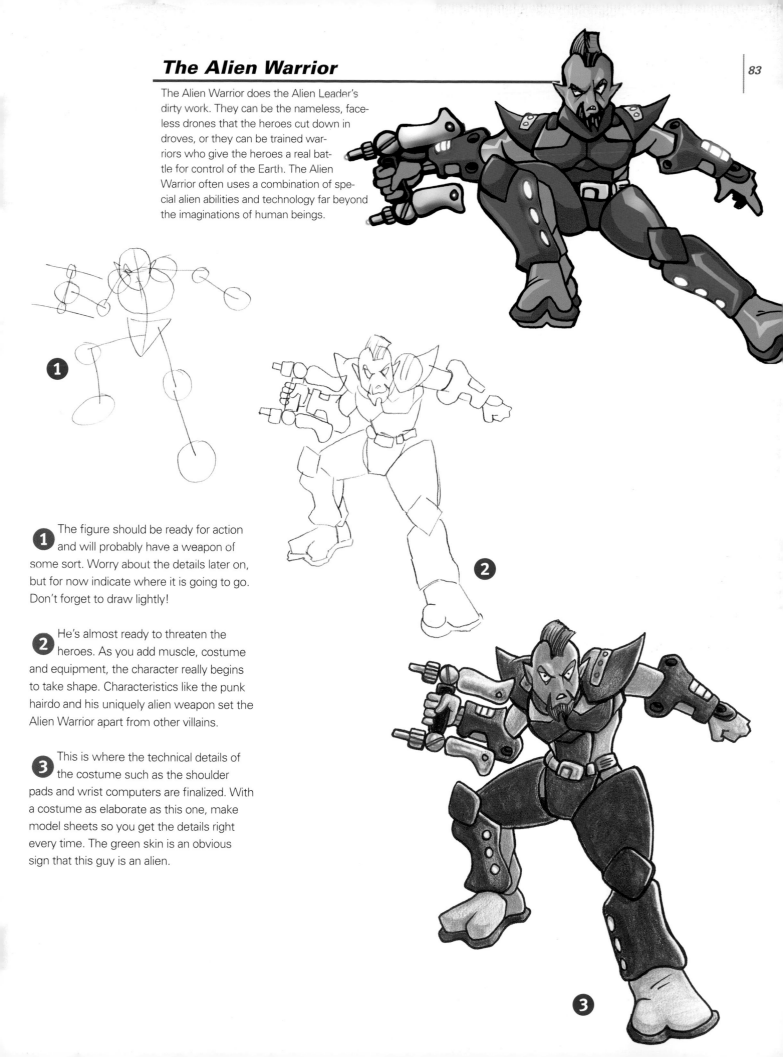

1 The figure should be ready for action and will probably have a weapon of some sort. Worry about the details later on, but for now indicate where it is going to go. Don't forget to draw lightly!

2 He's almost ready to threaten the heroes. As you add muscle, costume and equipment, the character really begins to take shape. Characteristics like the punk hairdo and his uniquely alien weapon set the Alien Warrior apart from other villains.

3 This is where the technical details of the costume such as the shoulder pads and wrist computers are finalized. With a costume as elaborate as this one, make model sheets so you get the details right every time. The green skin is an obvious sign that this guy is an alien.

Monsters

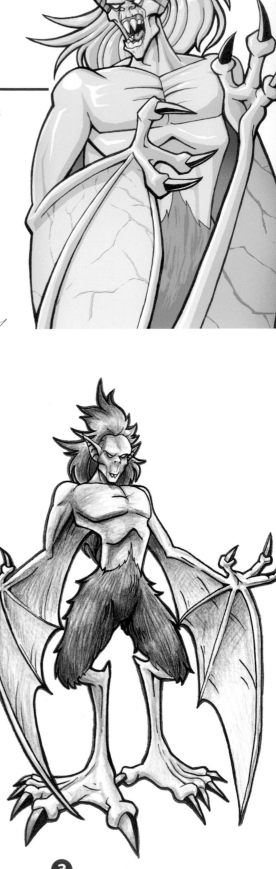

Monsters should surprise the reader with unexpected powers or abilities. Make them immune to power blasts or have them hoist armored cars over their heads. They need to appear scary even to Earth's mightiest heroes.

The Vampyre

This Vampyre is not the standard villain in black cape with pointy teeth. This Vampyre is alien and sinister, bat-like in appearance but grotesquely humanoid at the same time.

1 Block in the basic shapes, including the special features of the wings, legs and feet. The viewer is looking up at the figure, making the pose appear powerful and intimidating.

2 As you add details, try to make the figure more and more bat-like. Bat features inspired the wings, legs, ears, nose, fangs and feet of the figure. Try sketches of the Vampyre in action at this stage in your sketchbook. Draw him climbing walls, soaring the skies or skulking down corridors.

3 Some tension lines on the wings help show that they are a concave area of stretched skin. Use only a few lines to show the hair on the head and body. Reinforce the contour lines of the wings, chest and hair in colored pencil. Add a red glow around the figure to bring everything together and to help the image stand out. The red reminds us of blood or energy, like the infernal glow in the eyes of the Vampyre.

1

2

3

The Demon

The Demon should be a frightening manifestation of claws, horns, fire and brimstone. This creature is an embodiment of evil and will be a formidable opponent for even the toughest heroes.

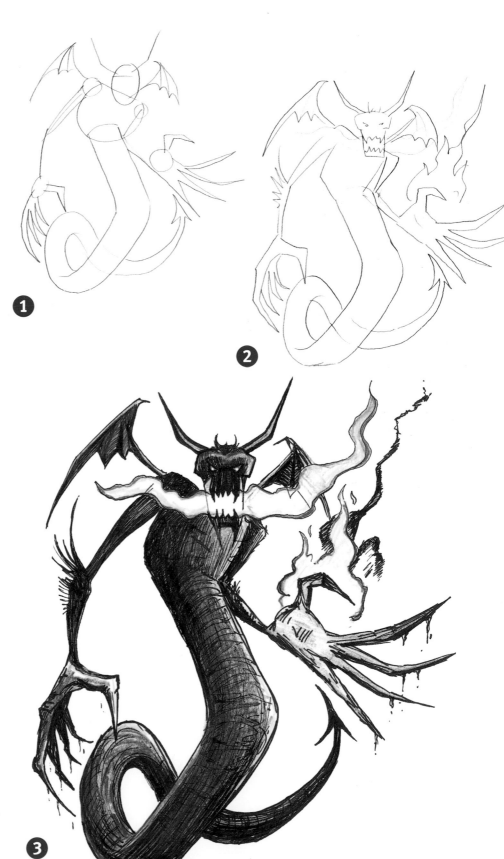

1 This is the most inhuman form yet. Keep the snake-like lower body as 3-D as possible; it should be drawn as a tube.

2 Add details such as claws, hair, fangs, horns and wings. Note how the left arm is drawn even though the figure will block it in the final drawing. Roughly place the flames and smoke coming from the hand on our right.

3 Keep the image loose and dark to reflect the pitted surface of the demon. The lines and crosshatching give the character a dark, brooding quality. It looks like it's made out of charcoal. The main light source for this image should be the flame rising from the hand on our right. Don't completely color in the flame; leave some areas light. The flame should be the brightest part of the drawing.

Robots

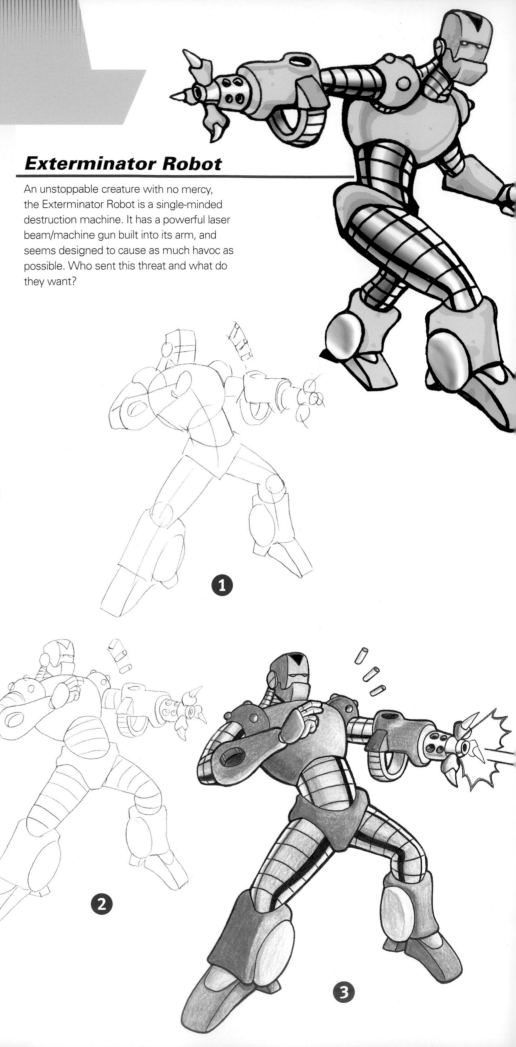

Robots are ideal opponents for superheroes. They can be horribly beaten and nobody feels bad because they are just creatures of metal and plastic, not flesh and blood.

Robots embody humanity's fears of becoming obsolete and being replaced by machines. There is also something chilling about the precision and cold logic of the robot. Robots provide an endless supply of untiring opponents that relentlessly pursue their goals.

1 Because someone or something built this robot, you can be a little creative with anatomy specifics. Start with the standard lines and circles to create the pose and place the figure in space. The pose is wide and dynamic. The robot seems to be bracing itself as it unleashes a blast of automatic-weapon fire.

2 Lines on the arms, legs and neck give the figure a flexible, metallic feel. The lines also help reinforce the contour lines that make the limbs appear 3-D. The face is strong and determined, with few details.

3 The light source seems to be the blast from the arm weapon. Areas of shadow and intense reflection, like on the arms and legs, will be darker. Details such as the bumps on the shoulders and the structure of the weapon and legs make the robot seem more convincing.

Exterminator Robot

An unstoppable creature with no mercy, the Exterminator Robot is a single-minded destruction machine. It has a powerful laser beam/machine gun built into its arm, and seems designed to cause as much havoc as possible. Who sent this threat and what do they want?

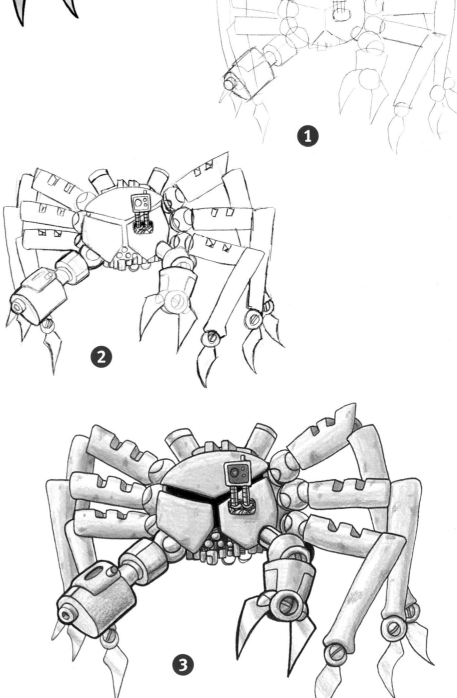

Crab Bot

The Crab Bot seems alien, almost insect-like. The many legs, killer claws and blaster weapon would make a superhero scratch his head and wonder what to do first when confronted by this mechanical nightmare. Crab Bots could be more spider-like and shoot webs that tangle up their targets.

1 The anatomy is kind of complicated, so start with the basics. Draw each leg in relation to the other legs, and the torso needs to be able to support all of these limbs. Check resources on crabs and spiders to draw a convincing structure.

2 Draw the individual parts as they overlap each other. Technological details make this robot unique. Bolts and ball joints maintain the high-tech look. It wouldn't take much imagination to make this an organic creature, some sort of alien or mutant beast.

3 The details finalized, begin inking, remembering that the parts of the drawing that are heavily outlined will look closer to the viewer. Keep the lines to a minimum. As you color and shade, add details such as the rust and weathering spots. Diagonal lines on the feet and claws make them appear thin, metallic and blade-like. The red "eye" views everything relentlessly. Carefully finish some engine details in the back and technological details at the base so the lighting is consistent on the robot's surface.

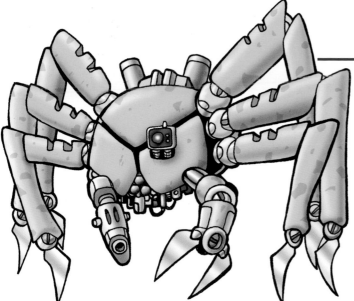

1

2

3

giant monsters *and* Robots

*T*he Giant Monster is one of the classic calamities that a group of heroes can face. Rampaging through the streets, seemingly unstoppable, it is the ultimate challenge for those with powers beyond mortal men.

What is a supergenius going to do to threaten heroes who can literally move mountains? Make a mountain that hits back. Giant Robots can come from a variety of sources in comics: alien warriors, military hardware, out-of-control prototypes, instruments of vengeance or malfunctioning helpers.

1 This rampaging lizard, a throwback to prehistoric times, could be the result of genetic engineering or a portal through time. Proportion isn't important here; just make him look intimidating. Put an everyday object like a car or lamppost in the drawing to help give the viewer a sense of scale. Viewing the monster from below makes the lizard appear larger and more imposing. The tail should be a fluid extension of the spine action line.

2 Block in details like the claws and facial features. Look at examples of lizards in nature or of dinosaurs in books for ideas.

3 The color choices are up to you. No one really knows what color dinosaur skin was, and modern lizards have a wide variety of colors to choose from. Define the surface texture of the monster. You don't have to draw every scale; a few here and there will be enough to imply scaly skin.

1

2

3

1 Make this humanoid robot's pose powerful and frightening. Draw from a low point of view to make it look bigger and more threatening. Use foreshortening to make the image appear like it is rising up into the sky. Add a car or lamppost to give the robot some sense of scale.

2 Add high-tech details to the robot, but don't add too much or it will be a pain to draw. This robot was inspired by robots in Japanese anime and manga. Suggest the surface at this point.

3 Giant robots don't have to be boring gray; make the colors as flashy as you like. Metallic surfaces show highlights and reflections in very predictable ways. Look at pictures of cars or jets to see how light is reflected and highlighted on those surfaces.

the basics of
Linear Perspective

Linear perspective is a technique that allows you to make the flat surface of your paper appear to have depth. Comic book artists are always pushing the limits of perspective to draw fantastic backgrounds that help establish the setting of the story and place characters in space. Here are the three types of perspective you need to know to create convincing 3-D settings.

One-Point

In one-point perspective, all the parallel lines in your drawing appear to meet at one point on the horizon, or eye-level line. All of the parallel lines that recede or go back in space must converge to this one vanishing point. The rest of the lines are parallel to the edges of the panel or paper. Imagine you were walking down a street lined with buildings. The lines of the road and the horizontal lines of the windows, doors and building bricks would all appear to point toward a single spot on the horizon.

In a one-point perspective drawing, the vanishing point acts as a natural focal point because all the lines seem to point toward that single spot.

Two-Point

This perspective allows for greater realism in a drawing. In two-point perspective, there are two vanishing points on the horizon where lines converge. Now imagine you're standing on a street corner, facing the corner of a building. The horizontal parallel lines on your right will appear to meet at one spot to your right on the horizon, and the lines on your left will seem to meet at another spot to your left on the horizon.

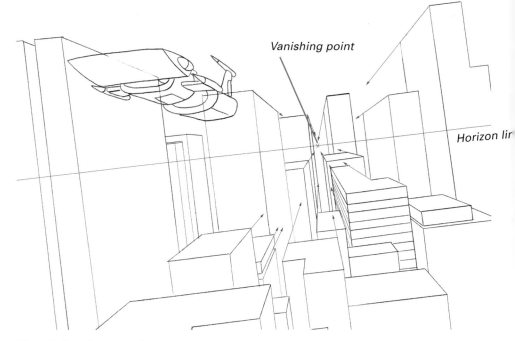

One-Point Perspective

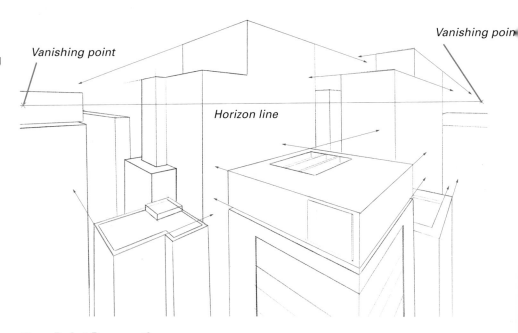

Two-Point Perspective

The only true horizontal line should be the horizon. The rest of the lines converge to their respective vanishing points on the appropriate angles. In two-point perspective, vertical lines should line up parallel to the edge of the panel.

Sometimes the vanishing points might be located outside of the boundary of your picture. Drawing shapes too close to the vanishing points could cause unwanted distortion. Consider taping an extending piece of paper containing the vanishing point to the page so you can actually see it as you draw

until you are more comfortable drawing in perspective.

Three-Point

Three-point perspective is a more expressive form of perspective drawing, which can produce some very dramatic results. Three vanishing points are chosen. The first two points are selected just as in two-point perspective, but the location of the third point depends on whether you are looking up at your subject or down on it.

Place the third vanishing point at the top of the page if you are looking up. For example, if you are looking up at an office building, the floors above your eye level will appear to get smaller and smaller and the shape of the building will appear as if it is being drawn up toward the third vanishing point. If you are looking down at the building, then the third vanishing point will appear to drop off the bottom of the page. In this case, the floors *below* you will appear gradually smaller.

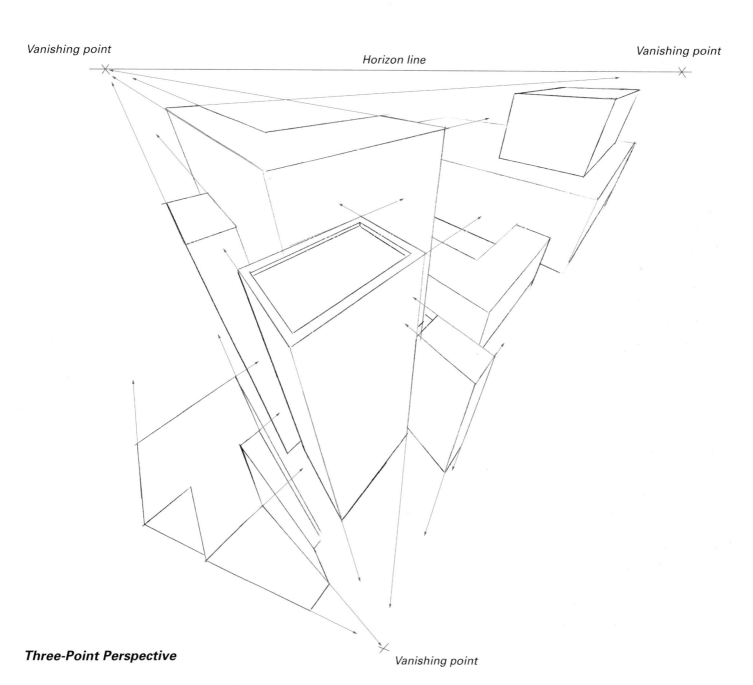

Vanishing point

Horizon line

Vanishing point

Three-Point Perspective

Vanishing point

drawing figures in Perspective

The same rules of perspective that apply to things like buildings apply to the human figure. Characters should be in proportion with their surroundings. Doors in the background should never appear too small for the character to enter, or too large. Everything must relate proportionally with everything else as it recedes into the perceived space. It's all about relative sizes and how objects that are farther away appear smaller.

Always keep in mind the viewer's perspective when you are drawing your characters. The horizon line is the eye-level line. Any character above or below this line will appear to be above or below the viewer.

Draw Cylinders as You See Them

One very common drawing mistake most beginners make is drawing the bottom of a cylinder flat. We know that the bottom of a soda can is flat, but when we look at a cylinder in space, we can clearly see that the bottom of the object appears to be more of an ellipse or oval shape. The same is true for the top: the oval gets narrower as it approaches the horizon line and disappears when it rises above the horizon line. We then see the bottom of the cylinder as it rises farther above the line.

To correctly draw an ellipse, draw a square in perspective first, then draw diagonal lines from corner to corner to locate the center of the square at the intersection. The ellipse can then be drawn as four curves that touch the sides of the square at four points.

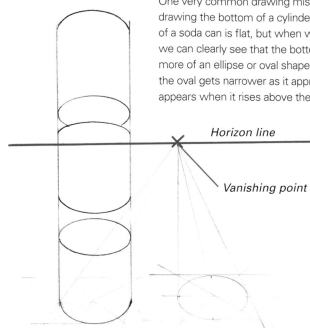

Horizon line

Vanishing point

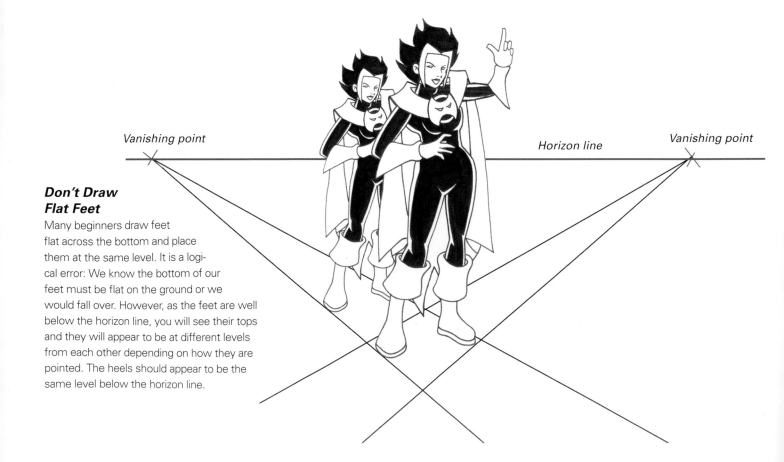

Vanishing point

Horizon line

Vanishing point

Don't Draw Flat Feet

Many beginners draw feet flat across the bottom and place them at the same level. It is a logical error: We know the bottom of our feet must be flat on the ground or we would fall over. However, as the feet are well below the horizon line, you will see their tops and they will appear to be at different levels from each other depending on how they are pointed. The heels should appear to be the same level below the horizon line.

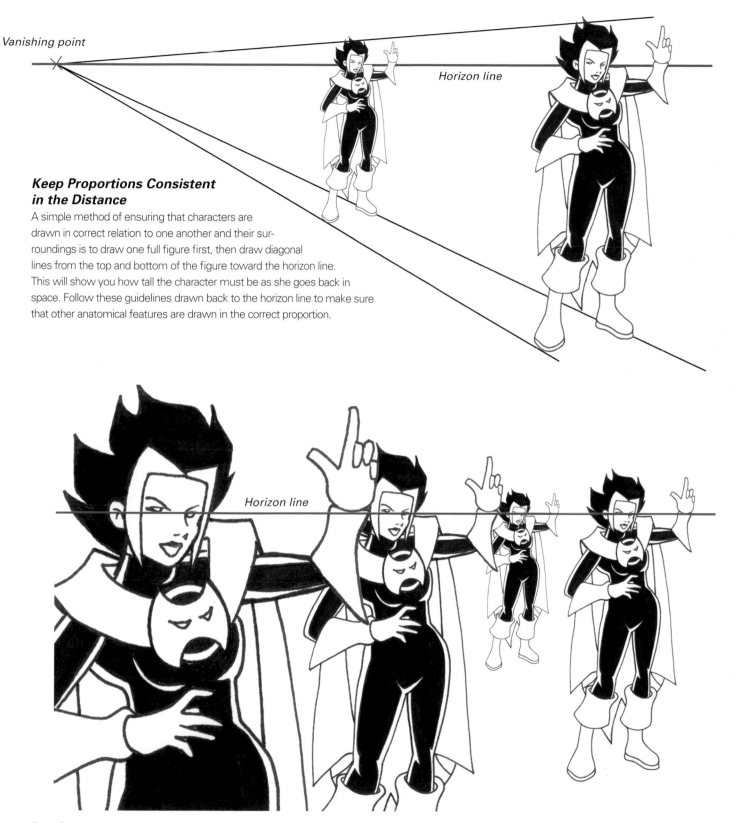

Vanishing point

Horizon line

Keep Proportions Consistent in the Distance

A simple method of ensuring that characters are drawn in correct relation to one another and their surroundings is to draw one full figure first, then draw diagonal lines from the top and bottom of the figure toward the horizon line. This will show you how tall the character must be as she goes back in space. Follow these guidelines drawn back to the horizon line to make sure that other anatomical features are drawn in the correct proportion.

Horizon line

Eye Contact

Characters whose eyes are located at the horizon line are the same height as the viewer. They will become the focal point of that drawing because they directly engage the viewer.

emergency
Response Workers

Superpowered battles have a way of doing tremendous property damage. Someone's got to put out the fires and cuff the bad guys once the guys in the tights are through.

Balancing fantasy and reality is a challenge when depicting "real world" elements in a comic. Adding emergency response workers will help make your scenes more realistic. You may want to research uniforms and equipment—colors and styles will vary depending on the department's location.

1 This image is developed more than some of the lessons, but you can see the basic shapes that create the figure with some specific details blocked in. Keep in mind that all the parts of the figure and equipment are cylinders, spheres and cubes.

2 Clean up the image and establish the darks and details. The uniform presented here is sort of a "classic" police uniform seen in movies and television. Many law enforcement officers wear bulletproof vests and carry radio equipment.

3 Metallic surfaces such as the handcuffs, badges and the gun should have areas of reflection and highlights. Create areas of light and shadow that reveal the 3-D form of the figure.

Police

Police are the thin blue line between society and lawlessness. In comics, the police often have a love/hate relationship with costumed heroes. They appreciate the help but are afraid that the so-called heroes are really just as dangerous as the villains.

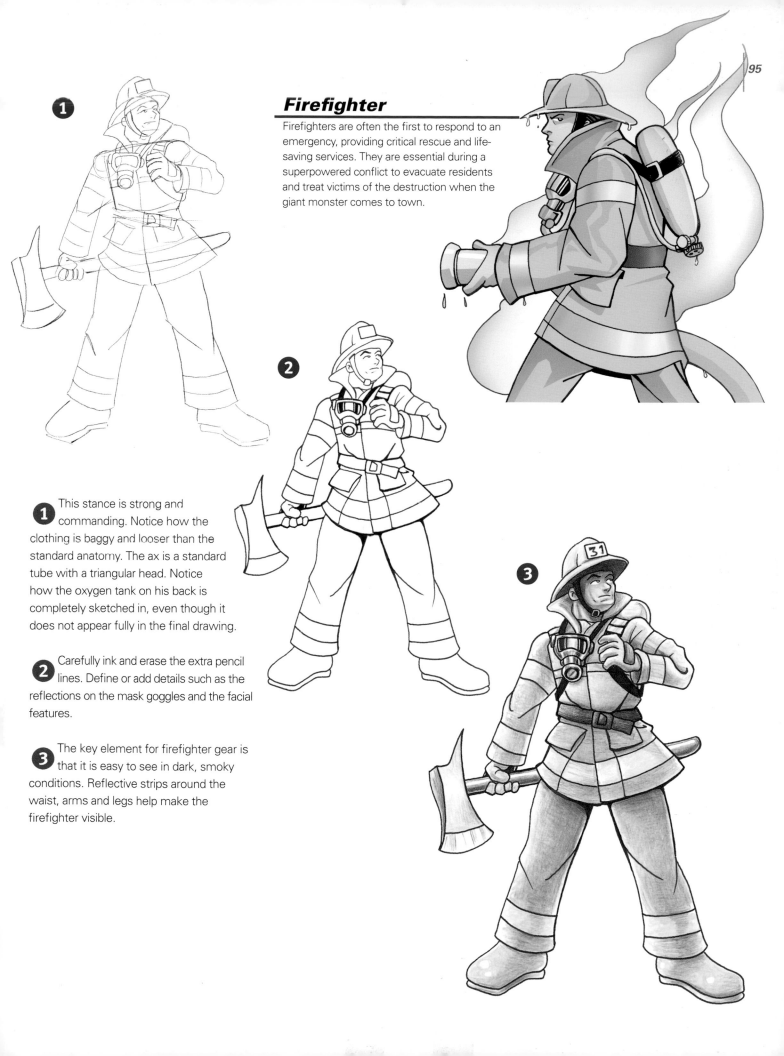

Firefighter

Firefighters are often the first to respond to an emergency, providing critical rescue and life-saving services. They are essential during a superpowered conflict to evacuate residents and treat victims of the destruction when the giant monster comes to town.

1 This stance is strong and commanding. Notice how the clothing is baggy and looser than the standard anatomy. The ax is a standard tube with a triangular head. Notice how the oxygen tank on his back is completely sketched in, even though it does not appear fully in the final drawing.

2 Carefully ink and erase the extra pencil lines. Define or add details such as the reflections on the mask goggles and the facial features.

3 The key element for firefighter gear is that it is easy to see in dark, smoky conditions. Reflective strips around the waist, arms and legs help make the firefighter visible.

innocent
Bystanders

Power with responsibility is the code of the superhero. Reckless villains buying time to escape often fire blasts into crowded streets, endangering innocent bystanders. Make innocent bystanders more than just extras—they are why your hero is fighting the good fight.

1 The pose is simple but full of energy and enthusiasm. Remember that children have different proportions than adults. Notice in particular that the head is very large in proportion to the rest of the figure.

2 Erasing the extra lines reveals a fairly simple figure. Rolled-up jean cuffs and shoes with laces and logos add realism to the drawing.

3 If there are too many heavy pencil lines that were erased after step 1, you might see "ghost lines" where they have indented the paper. Applying more pressure when coloring can get rid of most of these lines, but it's easier to avoid them from the start by doing the initial pencilling with a light hand.

Little Kid

Little Kids love superheroes. They often risk life and limb to catch a glimpse of their favorite hero as he soars by. Little kids also provide convenient "rescue me" moments as they get stuck in wells, up trees and on railway tracks.

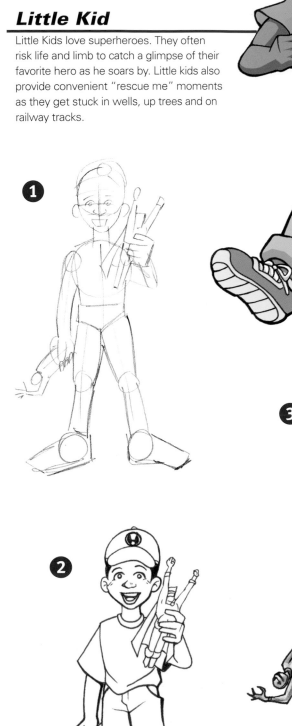

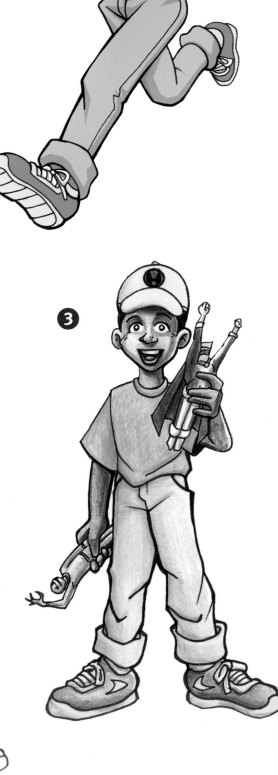

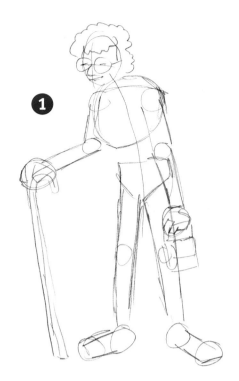

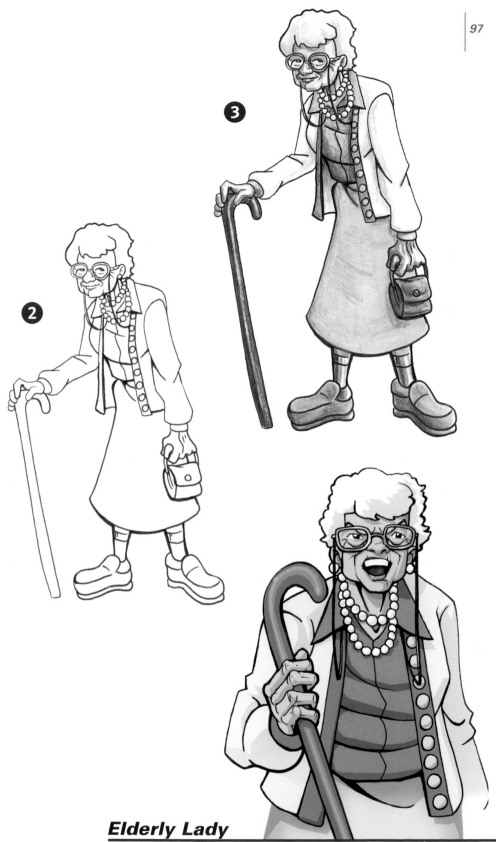

1 Elderly people are often stooped and seem slightly smaller than standard-proportioned adults. Even though clothing will cover some of the anatomy, you should still sketch the legs and torso so you know exactly how the figure is standing.

2 Clean up the linework and add details (buttons, pearl necklace, earrings, glasses and wrinkles). Don't overdo it; suggest rather than draw every little detail.

3 Notice how some details, such as the wrinkles on the hands, neck and face, are reinforced with careful shading. Avoid coloring areas with a single color. Use another color for shadow, or simply vary the pressure as you draw so you end up with darker and lighter areas of a color.

Elderly Lady

She's not going anywhere fast, but she's feisty! She doesn't take any back talk from anyone, so don't even think about it. With a whack of her cane she can set the meanest villain straight, but she'll probably need someone with superpowers to finish the job.

Super Car

When putting together a story, you'll need to be able to draw your superhero doing any number of things—maybe even driving. Super-heroes should travel in style. One comic book tradition is the souped-up supercar that sports an array of special built-in gadgets and weapons to help fight crime. The car is usually destroyed in the process of saving the day, but there's always a backup ready to go.

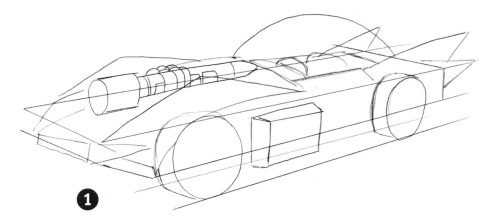

1 Use guidelines that go back in space to help your final drawing look realistic. The vehicle is really just a collection of tubes, spheres and boxes.

Clean up some of the lines and establish some of the trickier details such as the front of the car. Notice how the front gathers into a point. Block in the jet engine and fins, and have the shell of the car cover the top of the wheels. Borrow details from various vehicles to create the supercar.

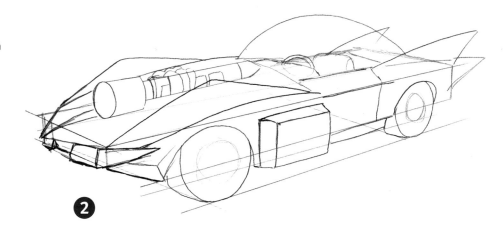

3 The dark interior suits the mysterious nature of the vehicle and its owner. The police light on top of the car suggests that this might be an official law enforcement hero. Make the metal look reflective, with clear divisions of light and dark. Use reference photos as you shade to help make the surface look more realistic.

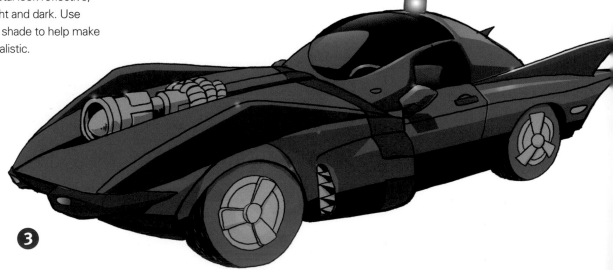

Truck

*E*very superhero needs a truck to hoist over his head and hurl at the bad guys.

1 The back of the truck is pretty straight-forward; most of your energy will be spent on the cab of the vehicle. Details on the dashboard, windows and front of the vehicle require some observation of real or model trucks.

2 Complete the details and erase extra guidelines. Lights, windshield wipers and big rearview mirrors were added after looking at reference photos of similar trucks. The more authentic the details, the more convincing your vehicle will be.

3 Color and shade using a consistent light source so the truck looks 3-D. The basic shapes you used to originally draw the vehicle will help you understand what you need to do to properly shade the vehicle.

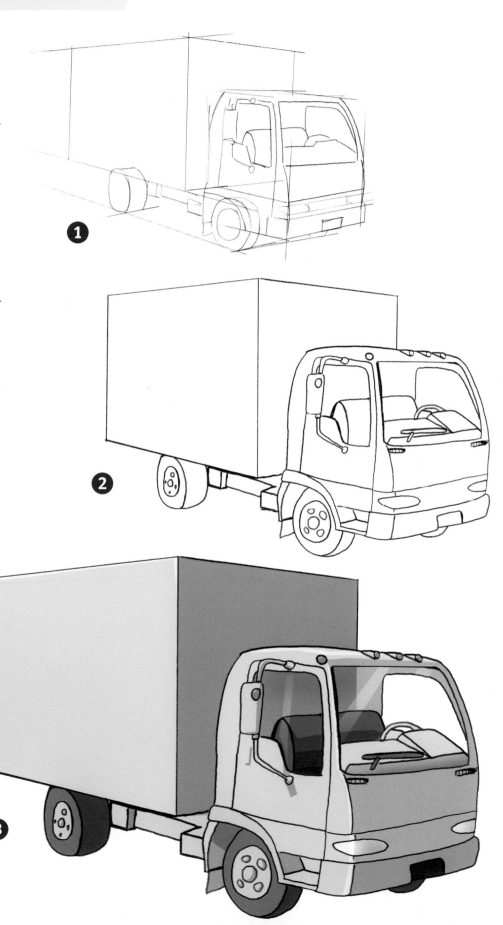

super
Technology

Cars, jets, robots and even figures are all built out of the same types of forms and shapes. Spend time doodling to figure out how things are put together. When you get comfortable drawing this way, you should be able to take an image of an object in your imagination and mentally rotate it, checking out every side.

If you don't have an easy time visualizing, build a toy collection of basic vehicles, action figures and other props. Details and different angles can be drawn from these toys. Try filling pages of your sketchbook on this and you will be on the path to becoming a much stronger artist.

This character is using a rabbit ear to enhance some sort of hands-free communication device.

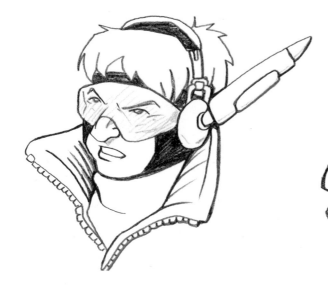

Rabbit Ears

Rabbit ears appear from time to time in comics. The basic shape is a thin rectangle that rises from the surface of the object or character. They're called rabbit or bunny ears because they often act as sensors or antennae. However, they may have other purposes, serving as computer processors or lights.

This spaceship has many rabbit ears that seem to be some kind of rudders or wings. Knowing that there is no use for wings on spaceships (there is no air in space, after all), these rabbit ears could alternately be used as powerful communication devices or some sort of energy collector.

The Bolt

This is a simple, stubby cylinder that attaches to an object or character. The purpose of the bolt is open to interpretation. It can appear to be some kind of venting unit, a tightening bolt used to secure technology or take pressure off hydraulics, a container of cooling fluid or fuel, a lightbulb or some sort of exhaust system.

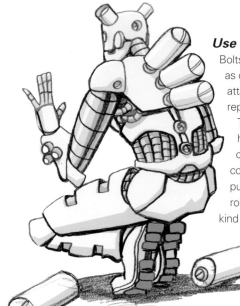

Use Your Imagination!

Bolts are used on this character as coolant tubes that are attached to the spine and replaced on a regular basis. The bolts on the robot's head appear to be simply cosmetic, but they could contain memory units or computers. The mini-bolts on the robot's arm could be some kind of weapon.

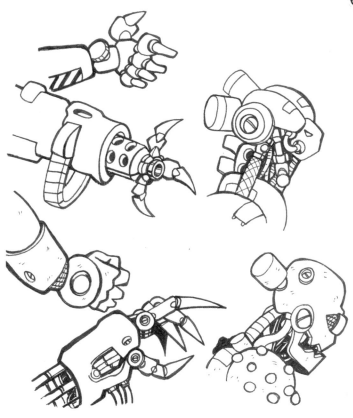

Advanced Technology

A wide variety of technological elements can be found in these robot studies. Bolts, wires, hydraulic tubes, ammunition belts, servos and sensors are all represented. Even though some of this technology does not currently exist, you can still be consistent and have an internal logic in your comics that will help people believe in what you draw.

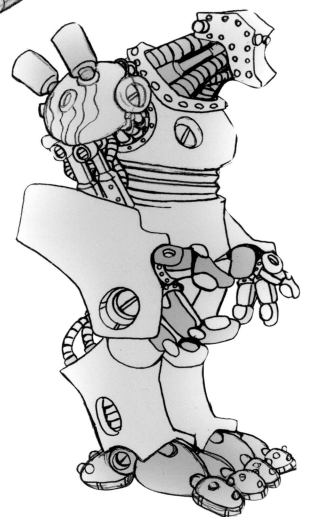

Big Bruiser

This robot has the elements of bolts and wires working together. Some bolts are big and seem to be leaking fluid, while others are small and support joints. Wires and tubes distribute fluid and provide a complex hydraulic system for the robot. You may not know much about how robots really work, but be consistent and your work will convince the viewer that you know what you are doing.

Spacefighter

You have the opportunity to make anything you want look like an alien spacefighter. The stranger the combination of shapes, the more alien it will appear. The inspiration for this vehicle was the shape of a squid and a wasp.

1 Use a strong central axis line and crossing lines to establish the basic shape, and then build the details on top of this framework. The shapes should be loose and exploratory. You want to express the idea of the spaceship at this point, not painstakingly draw every detail.

2 Carefully erase unwanted lines, reinforce the outline and add details. The insect-like nature of the vehicle is much more obvious at this stage. The pincers in the front might be some sort of docking clamps or a weapon.

3 Add interesting patterns, textures and colors. Make sure the vehicle will stand out against the blackness of space. Shading gradually from light to dark should make all those rounded forms look 3-D.

1

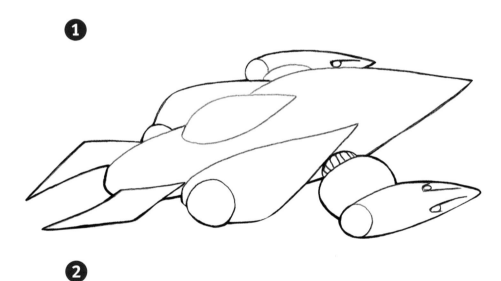

2

3

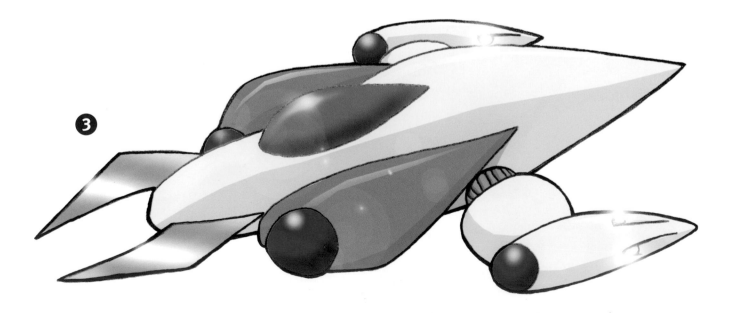

alien
Space Pod

*I*t's the kind of vehicle that streaks out of the sky, crashes into a farmer's field and then starts unleashing a horde of killer robots. The pod is more of a transport vessel than a battle craft.

1 Block in the guidelines. Use loose shapes to establish the design of the vehicle. Complex technology, when reduced to basic shapes, can be fun to draw. Is that a face on the front of the vehicle?

2 Clean up the extra lines and define the lines that are left. Notice how parts of the vehicle are hidden behind other parts. This adds to the realism and makes the vehicle look like it really exists in space. The technology appears almost alive.

3 Color and shade the vehicle to enhance its alien appearance. Keep it simple. You want to have a classic, cool design that is fun to draw. If you get too complicated, you'll never want to draw the thing again.

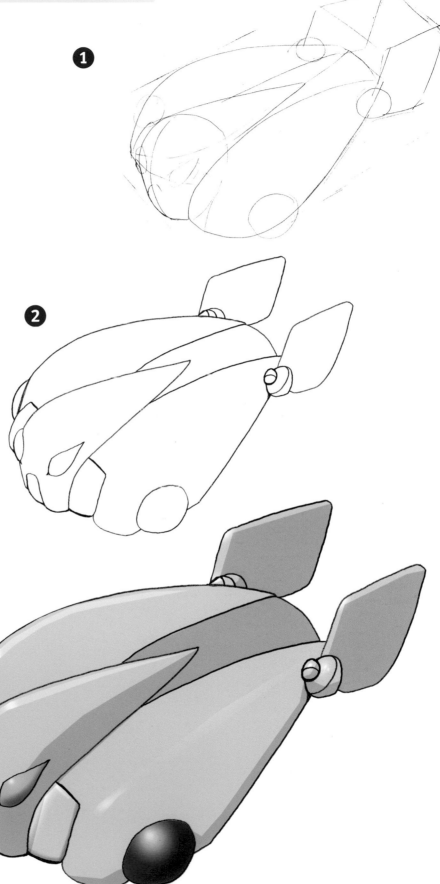

Cityscape

*T*he background of a scene adds much to the story, creating mood and a sense of place. Most superhero stories take place in a city, real or fictional. Setting a story in a fictional city is nice because everything can be tailored to support the story and characters. In a way, the city can be considered another character in the comic.

Keep a file of photos and drawings of buildings and streets. Even common objects such as fire hydrants and vending machines make the setting seem more realistic.

1 Start with the basics: a horizon line and two vanishing points. Draw a few vertical lines that will become the corners of buildings.

2 Use a ruler and draw lines heading back in space, leading to the two vanishing points, to create a collection of boxes. These boxes will become the buildings in your final drawing.

3 Use reference photos and sketches to add architectural detail to your boxes. Details such as the signs on the diner and the brick guidelines just follow the same rules as the rest of the drawing. Everything must go back toward the vanishing points.

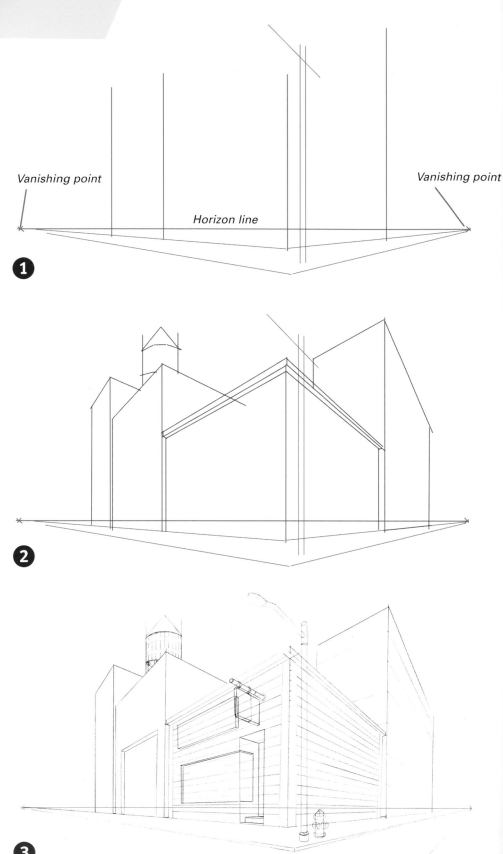

Vanishing point

Vanishing point

Horizon line

1

2

3

4 All those extra lines can get confusing. When you erase them, the buildings seem to take shape. You may also crop the image at any time. By zooming in and making your vanishing points disappear off the panel, the image will look more realistic and natural. Remember that objects that are farther away will appear smaller, be overlapped by closer objects and have less detail.

5 Colors on distant buildings should be less intense than on the buildings in the foreground. Consider each major light source as you finish your drawing. You may feel the need to zoom in further and ignore the remaining part of the drawing.

4

5

Villain's Lair

No one really knows what all the equipment in the villain's lair actually does, but it should look impressive. The lair should reflect the origin and character of the villain. High-tech villains, aliens and mad scientists will probably have lots of gadgets and machines. This high-tech look may not be as appropriate for villains who are monsters or wizards.

1 All those lines may look intimidating, but don't panic. This is just two-point perspective. Start with the horizon line and the two vanishing points. Then, establish the floor (in black). Raise the walls straight up from the floor to complete the room. Block in the door and the central machine.

2 After you've blocked in everything and checked the perspective, begin to add details. The "X" on the machine will help you find the center so a circle we'll add later will appear to be in perspective.

3 Lots of changes appear as new items are added. The machines on the ceiling are simple cylinders drawn in perspective. They drop down at haphazard angles and appear clustered and randomly placed. Other details, such as the central machine's pipes, the computer terminal and the barrel alcove, are drawn using basic shapes that all head back to the vanishing points.

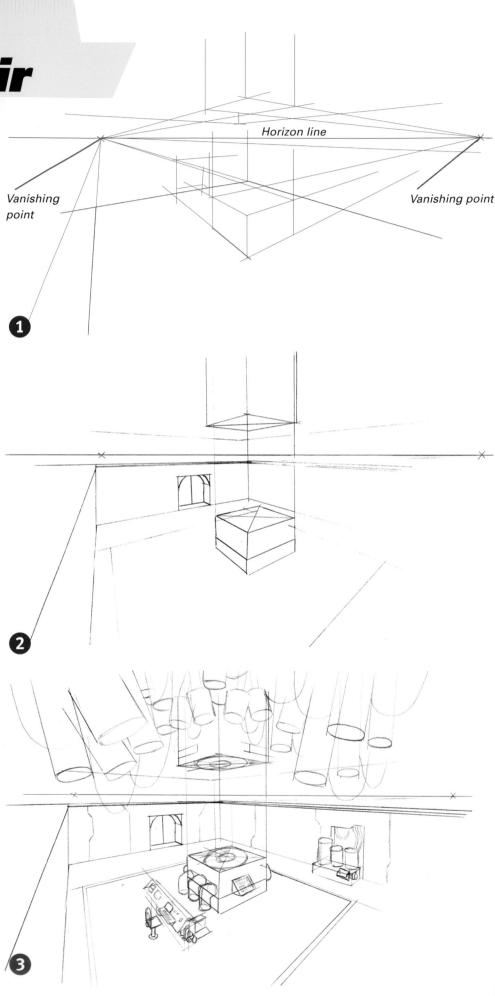

Horizon line

Vanishing point

Vanishing point

4 What a difference inking makes! A clearer image has taken shape. The stripes on the floor go back to a different point on the horizon line because they are at a different angle than the walls. This sets them apart and creates a visually interesting space. Detail other technical aspects of the room, such as tubes and wires.

5 The stripes have become hazard markers and the central machine seems to be producing a powerful energy force. This could be a dimensional gateway, a dangerous weapon or how the villain gets his powers. The machine is the main light source even though several lights emit from the ceiling.

4

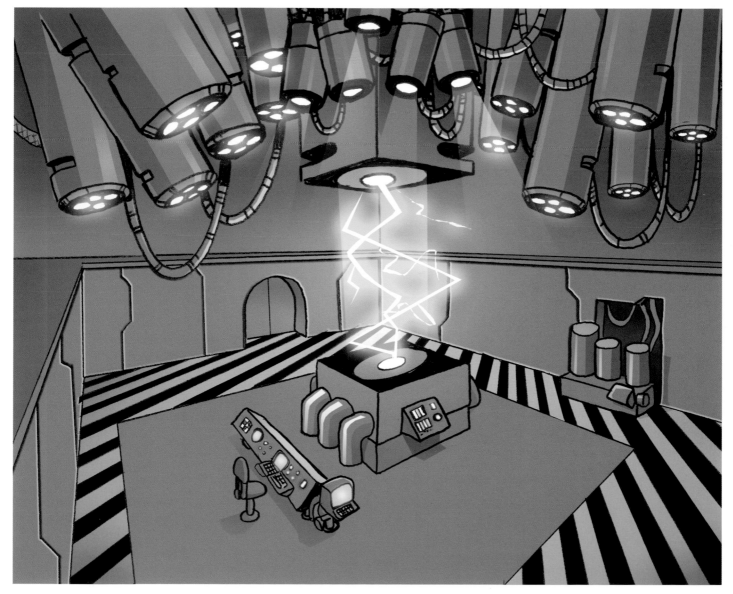

5

Alien World

Some of earth's most dangerous enemies come from distant planets, and so have some of earth's most heroic figures. These settings can draw upon ancient ruins, contemporary architecture or a unique combination of both.

1 Start with a horizon line and two vanishing points. Draw a few vertical lines to block in the basic structure of the room.

2 Now the room is beginning to take shape. Draw elements such as the stairs and the wall supports for the tower at a consistent angle. To get this angle as close as you can, draw a box in perspective and join the corners. This will give you a clear idea of the angle the stairs should take.

3 Clean up some of the rough lines and continue detailing the architectural features. An area of water is added on the floor to add an organic element to the otherwise geometric setting. This is a very mysterious setting. Are these the ruins of an alien civilization or is it the castle of a galactic warlord?

4 Steps, lights, alien writing and other details make the drawing feel complete. Erase the horizon line, vanishing points and any remaining guidelines.

5 This *is* an alien world. The sky is a strange salmon color; the stone looks like green marble. The lighting is moody and atmospheric. The structures outside are toned down compared to the deep contrasts inside. The water reflects the lights and architectural details of the room. The main light source is external sunlight that is falling on the back and side walls on the left. Other lighting comes from artificial sources, each affecting the surrounding area.

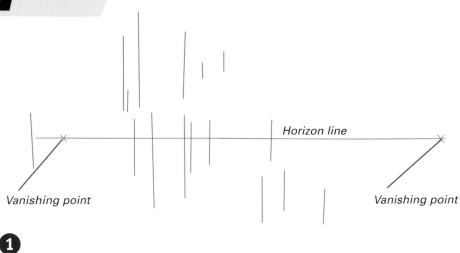

Horizon line

Vanishing point

Vanishing point

1

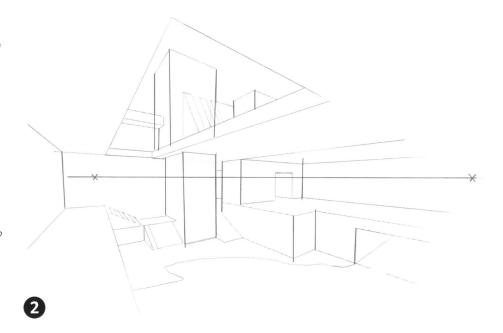

2

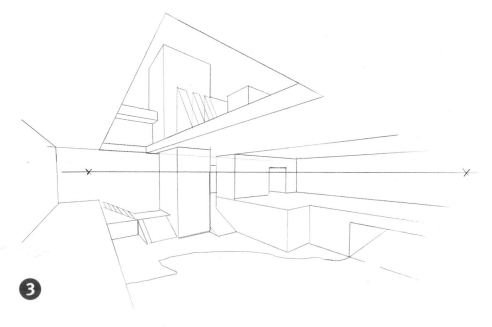

3

4

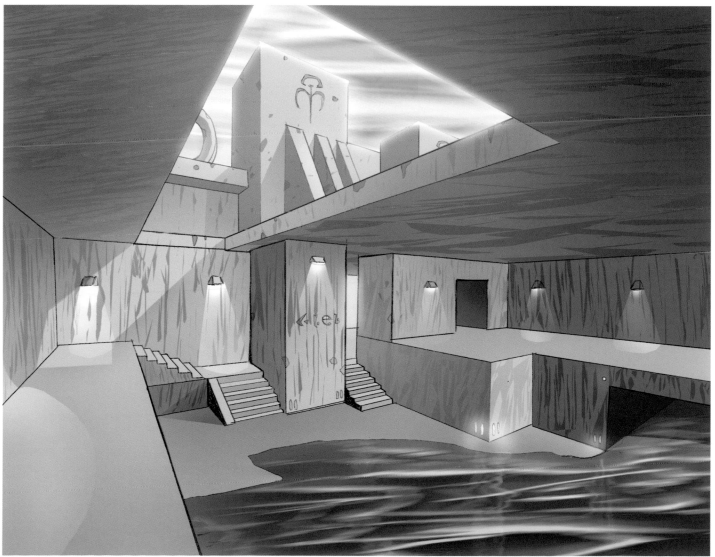

5

basic elements of a
Comic Book Page

Comic book art has also been called sequential art—that is, a series of images and words that are strung together to tell a story. The comic book artist must be able to draw almost anyone or anything acting in every possible way, but you also must connect these individual images to create a bigger picture—the story.

It is important to think of comics as a medium, not a genre. It is a way of telling a story, not the story itself. Comics encompass all kinds of genres: history, drama, biography, romance, science fiction, fantasy, horror, comedy, action adventure and many more.

Let's look at the basic elements of a comic book page.

Narrative Caption
Narration is usually written in rectangular boxes that overlap the artwork.

Panel
One of the many illustrations arranged in a storytelling sequence.

Surface
Most comics are drawn on 11" x 17" (28cm x 43cm) two-ply bristol board sheets. The artwork area is usually 10" x 15" (25cm x 38cm).

Thought Balloon
A cloud-like balloon that reveals the thoughts of a character.

No Panel Border
Create a more dynamic image and show more of a character by breaking him out of the panel.

Yelling Word Balloon
This balloon is jagged and the lettering is much larger.

Bold Lettering
Larger and/or darker lettering means that those words are stressed or said louder.

Word Balloon
The arrow points to whomever is speaking. A dotted-line balloon indicates whispering.

Gutter
The space between the panels. Keep your gutters consistent.

Panel Variety
Change panel shape from time to time to hold the eye of the reader.

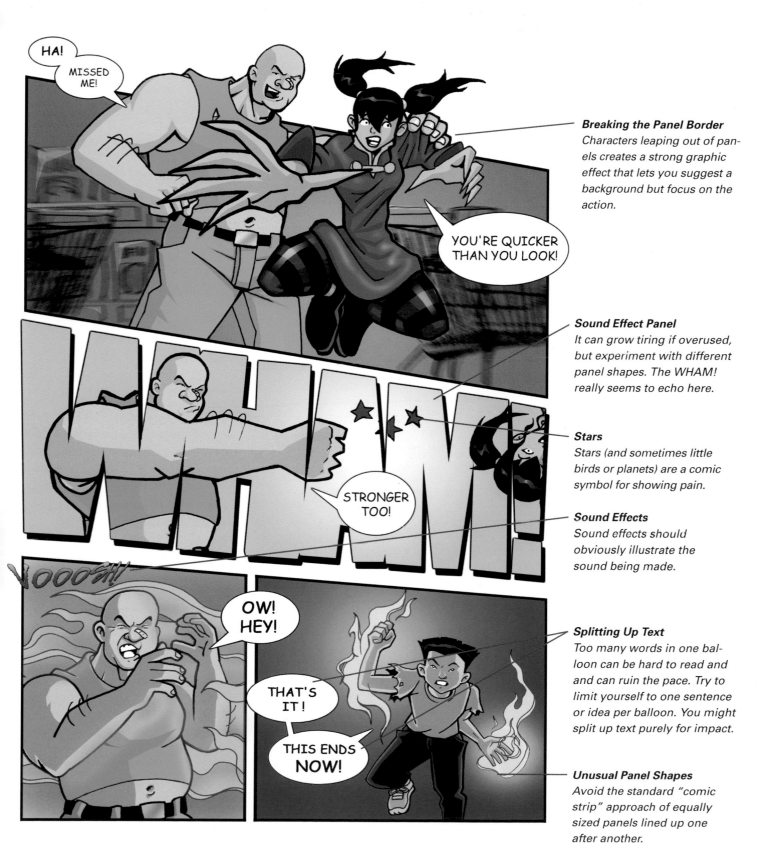

Breaking the Panel Border
Characters leaping out of panels creates a strong graphic effect that lets you suggest a background but focus on the action.

Sound Effect Panel
It can grow tiring if overused, but experiment with different panel shapes. The WHAM! really seems to echo here.

Stars
Stars (and sometimes little birds or planets) are a comic symbol for showing pain.

Sound Effects
Sound effects should obviously illustrate the sound being made.

Splitting Up Text
Too many words in one balloon can be hard to read and and can ruin the pace. Try to limit yourself to one sentence or idea per balloon. You might split up text purely for impact.

Unusual Panel Shapes
Avoid the standard "comic strip" approach of equally sized panels lined up one after another.

planning a comic page:
How It's Done

The idea for the comic comes first. You might use a script or a thumbnail layout to plan your story. A script is a written description of everything that happens or is said in the comic. One disadvantage of the script is that there is an abstract sense of what can fit on a page, and often the writer frustrates the artist by trying to show too much in one page or panel.

A thumbnail layout involves planning the story visually from the beginning, then adding dialogue later to enhance the visual storytelling. Thumbnails are small, rough drawings that are tiny versions of your final pages.

The intense deadlines of professional comics usually mean that a single issue is created by a team of specialists:

- *the writer, who dreams up the story and dialogue*
- *the penciller, who turns the story into visual images*
- *the inker, who carefully draws over and enhances the pencil lines*
- *the letterer, who writes the dialogue in caption boxes and word balloons*
- *the colorist, who colors and shades each panel*

Making a Rough Thumbnail Layout
This page was drawn in a notebook along with the rest of the story's pages. The images are very loose and are meant to be guidelines for the artist to get ideas for general composition and pacing.

Tightening Up the Images
At this stage the goal is to develop strong, powerful images and to make sure that each panel furthers the story. The lines are still drawn lightly, but tighter and on good paper. If you were lettering your page by hand, you would block in your word balloons at this time.

Final Pencilling

The details are developed further, and the finished pencils are carefully shaded in. Some areas may be marked with a simple "X" to indicate that they should be inked in black.

Inking

Many different tools can be used for inking (dip pen, technical pen, felt-tip marker or brush). Be careful with the ink since it doesn't erase. Correct minor errors with white paint or correction fluid. Erase the pencil lines carefully, long after the ink and paint have dried.

Coloring

Most comics today are colored with a computer, but some can be hand-colored using a variety of media such as colored pencil, markers and paints.

Adding Word Balloons and Lettering

Some artists prefer to place the balloons as they pencil the art. Arranging balloons and text on a computer allows for greater flexibility and a more uniform look. The eye should flow from balloon to balloon in conjunction with the way the art moves your eye around the page.

Lettering can be done by hand on the original inked page, but it is usually done using computers. When hand-lettering, keep it neat, tidy and big enough to be legible when the artwork is printed. Spelling mistakes can make all your hard work look bad, so get someone to proofread your script before you start lettering.

panel
Composition 101

Not every panel needs to be an artistic masterpiece. That would be like trying to make every sentence in a novel a literary triumph. Sometimes a panel just serves to move the story along. Comic book artists usually save their focus for the "money" shot—the key image that sums up the events of the page.

Two ways to keep your panels interesting are applying the Rule of Thirds and using different points of view. The Rule of Thirds offers eye-pleasing options for placing your subject or center of interest. And, since a series of talking heads or full figures standing around panel after panel gets old quickly, drawing characters from different points of view keeps the page interesting.

The Rule of Thirds

The panel is like a picture frame that surrounds the subject. Try to avoid placing your subject dead-center. Divide the panel into equal thirds by drawing three horizontal lines and three vertical lines. The focal point of any panel should be at one of the intersections.

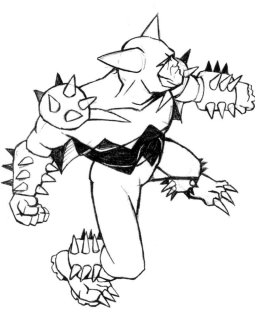

Bird's-Eye View

This view is from above, looking down. The horizon line is high in the picture and the viewer has the impression of being tall or up high. This view is effective for making a character appear anxious, unsure or weak, but it can also be used to show another character's point of view.

Eye-Level View

This view has us looking at a character straight-on. The horizon line is in the middle of the picture. There is no distortion of the image. The impression of this view is equality and calm.

Worm's-Eye View

This view is from below, looking up. The horizon line is low in the picture and the viewer has the impression of being small. This view is excellent for making a character appear imposing or powerful.

basic
Panel Shots

Just like a movie director, the comic book artist must consider if the image is going to be seen up close or from far away. These issues are usually dealt with in the script or the layout. Change the shot occasionally to make the page interesting and to place emphasis on specific elements and details.

Long Shot (Full Figure)

This shot shows the entire figure or figures in space. The details of the background are important but should not compete with the focus of the panel.

Extreme Long Shot (or Establishing Shot)

This shot establishes the setting and the character's relationship with it. Use proper perspective and create a full depth of field with a foreground, middle ground and background.

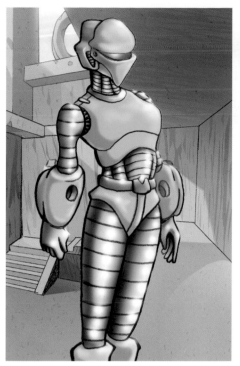

Knee Shot

This shot is useful for showing costume details or clarifying complex actions.

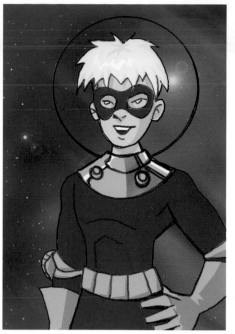

Medium Shot (Waist Up)

This waist-up shot allows for a clearer view of details, expressions and actions.

Framing the Image

Comic book artists have an advantage over photographers and filmmakers because they are not at all dependent on what they see or can't see. They are only limited by their imagination and technical ability. The artist has ultimate control over what a character looks like and does.

Use this freedom to have fun with framing your subject in the panel. Tilt the angle to make the image more intense or twisted. However, avoid overusing breaking the figure out of the panel. It is a powerful tool that draws attention to the action, but using it too much can lessen its impact, so use it wisely.

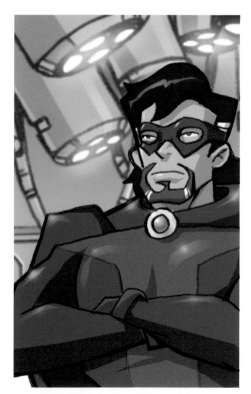

Medium Close-Up (Chest Up)

This chest-up shot is useful for focusing on the expressions and details of the face, but still provides information about the character's costume and surroundings.

Close-Up (Head Shot)

This is useful for reaction shots or expressing emotions. This shot could show another detail such as hands, feet or an object.

Extreme Close-Up

This shot is used to bring complete focus to a specific element or detail, whether it's a facial feature or an object.

designing a Story That Moves

Before you can draw anything in a story, you must know what your comic is all about. Try to plan everything before you begin drawing your first page. It helps to know from the beginning how you want the story to end so you always know where you're headed.

The flow of one image to another will tell a story, whether there is one or not. Randomly mix and match the panels on this page and you will get a wide range of stories. The basic elements of the story will remain, but the ultimate meaning will change. Some versions will make more sense than others, but we will work hard to take the leaps required to make sense of what is going on. It's the way our minds work. We want to make sense of what we experience. We want everything to be logical.

A picture really is worth a thousand words. The most effective comic book stories can be told without words. Comics are a truly visual medium, and it is often the images that first grab the attention of the reader. They should reveal what is going on with action, reaction, expression and mood.

How Panel Size Affects Eye Flow

Each of the first four panels is of equal size and (so the reader believes) of equal importance. Roughly the same amount of time is spent viewing each panel. We see the hero throw a punch; the thug crashes through the window. We see the hero's look of shock; the thug throws the broken glass.

The fifth panel, however; is bigger than all the rest. This can be very good for controlling where the reader looks and for how long. Big panels and lots of detail tend to slow down the reader. The fifth panel gives the reader some further information on the powers and attitudes of the hero. The large panel also seems to freeze the action, allowing the reader the chance to linger for a moment and enjoy the details.

The Rule of Thirds

The Rule of Thirds applies to full-page layout as well. The focal point of the page is often where the readers look first, whether that's where you want them to begin reading or not.

Splash Page

When one or two large panels dominates an entire page, it is called a splash page. This page introduces the reader to the action with a large establishing image. This image should provide all the details necessary to get the story moving and draw the reader into the comic. If your splash page has two panels, make sure that one is larger than the other so the page isn't cut into two equal halves.

Traditionally the first page of a comic was set aside for a splash page, but as the stories and mythologies of modern superheroes grow and evolve, the first page is increasingly used to introduce new readers to the characters and the story so far.

pacing and
Panel Flow

As the creator of your comic, you have ultimate control over where the readers look and how they approach your images. Stories are broken down page by page, panel by panel. Each panel presents a unique image that should stand on its own but also link from one image to the next to create the greater story.

You can manipulate how much time the reader spends on each image on a page. Smaller panels of roughly the same size are read quickly and move the story along. Like many quickly cut shots in a film, they will speed up the pace of the story and establish a rhythm. Larger panels demand attention and will hold the eye longer, especially if they have more detail.

Keep in mind the "big picture" as you lay out your page. Mix up the size of your panels based on what is important to the story. If you pack the page with lots of tiny panels, the reader may zip through your story without catching key elements of visual information. If you are building the drama and suspense of the moment, draw a series of small, narrow panels. For a long, lingering shot that may set up the location of a scene, make the panel larger.

Remember that the missing elements will be filled in by the imagination of your readers. They will fill in the breaks between panels to imagine the passage of time and events from one panel to the next.

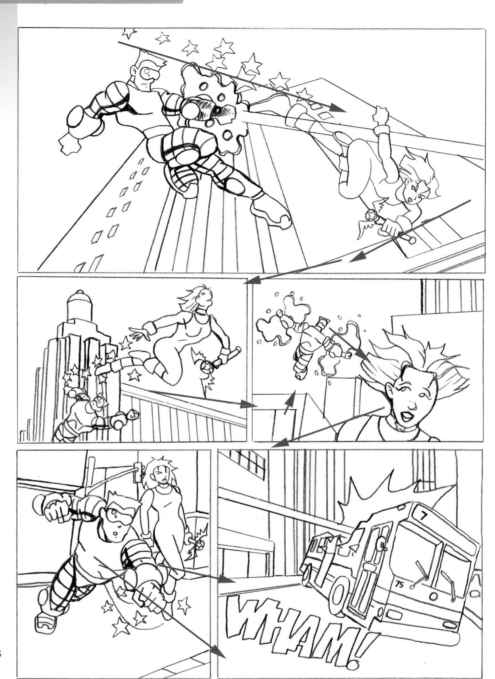

Leading the Reader's Eye Around the Page

Control how your story is revealed to the reader by using emphasis and leading lines to direct the eye from panel to panel. Emphasis occurs when an element dominates the panel and stands out. Larger character images and areas of high contrast can create emphasis. Leading lines are movement lines that lead the reader's eyes through the image and the page. They can be the direction of perspective lines or the way a figure is pointing or moving. Every panel should lead to the next.

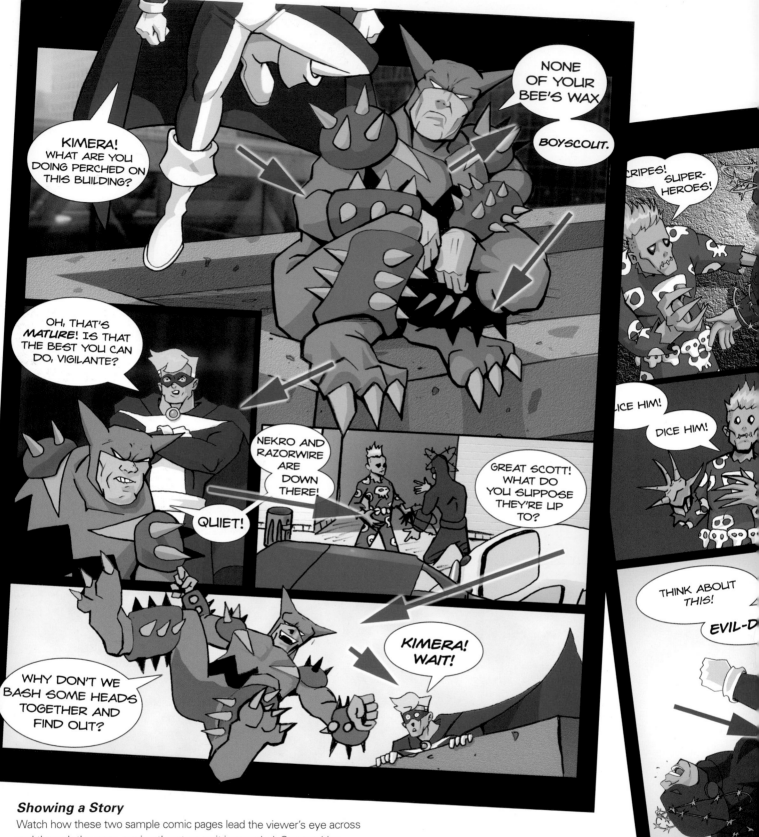

Showing a Story

Watch how these two sample comic pages lead the viewer's eye across and through the page, pacing the story as it is revealed. Composition rules and leading lines help create specific areas of emphasis and direct the gaze of the reader.

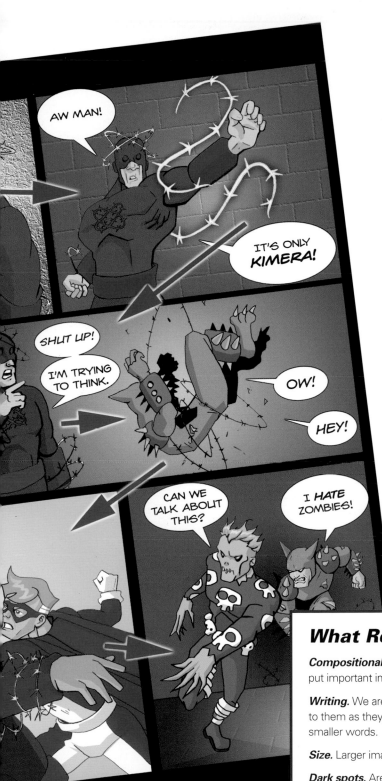

Zooming In

These panels of the same character help establish the mood and setting of the scene. Each image reveals something about the character's state of mind.

What Readers Notice First

Compositional focal points. Using the Rule of Thirds, you can find the best place to put important images not only within individual panels but on the entire page.

Writing. We are attracted to words when they appear in art. Our eyes are drawn to them as they contrast against the images. Larger words are usually read before smaller words.

Size. Larger images capture the reader's attention and hold the eye longer.

Dark spots. Areas of shadow or black will grab the eye, especially if they appear next to very light areas.

Detail. Detailed artwork, such as folds in a cape or complex technology, will hold the eye.

Faces. We are naturally attracted to other people's faces, especially the eyes.

Contrasting areas. Simple areas contrasted with complex areas—such as an object of no pattern on a patterned surface—catch the eye.

Distortion. Things that look funny, strange or deformed attract attention.

dynamic action
Between Characters

Superhero comics are all about action. If the most important element of all fiction is conflict, then you must be prepared to draw at least a few panels showing the conflicts in your story. These conflicts can range from a heated exchange of words to climactic hand-to-hand combat.

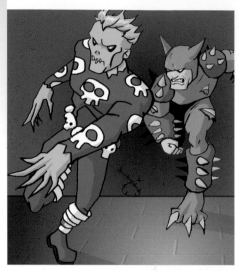

Chasing

The bad guy might be trying to get away, or a teammate has pushed too many buttons, and the chase is on! Keep the action up close and personal. Focus on the characters—their expressions and attitudes should change as the chase progresses. The chased should be running full-speed, and the chaser should appear to be getting closer and closer. It is time consuming to repeatedly draw all the backgrounds that help show the progression of the chase, but this is important to make the chase look realistic. Throw in dangerous or unusual terrain, innocent bystanders and hazards such as busy streets or dead ends.

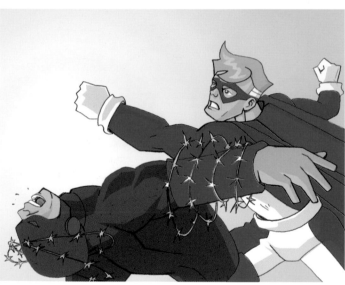

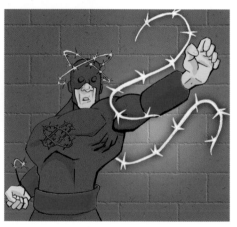

Superpowers

The possible ways that characters can interact using superpowers is endless. Every power will be different and every target will respond differently.

Fighting

Fight sequences can take up a lot of space, and showing every detail of the battle can become tedious for the reader as well as the artist. The key to keeping your sanity and drawing some cool fight scenes is to not draw every move or detail of a battle. Take shortcuts. For example, show a hero kicking in one panel and then the villain flying through the air in the next panel. The reader will fill in the blanks.

Talking and Arguing

It's a real challenge to make panel after panel of talking heads interesting and engaging. Be ready to reveal more about the characters and the words they are saying. Show what they are doing as they are talking. Change the angle to draw the reader into the picture, or focus on a significant detail that helps further the suspense or intrigue of the story.

Body language can reveal how characters feel about what they are saying or hearing and the person they're speaking with. Emphasize the facial and body expressions, and change the camera angle and placement of the characters to reinforce their relationship and status. The body language of the characters expresses much more than their words could ever say.

word balloons, lettering
and Sound Effects

Word balloons come in all shapes and sizes. Most of them have a small point or arrow that leads to the speaker. Narrative captions are usually contained in plain boxes. Remember to split text into different balloons to avoid long blocks of text, indicate pauses or emphasize certain words.

If you are not using a computer to do the lettering, then make sure to do your hand-lettering clearly and carefully. Spelling mistakes will reflect poorly on your abilities even if the art is beautiful. Make a sample alphabet in your own writing to refer to as needed. You may find personal touches that will add some character to your lettering. You can also be much more expressive when lettering is done by hand. Emphasizing or bolding certain words adds emotion to the dialogue. You could give certain characters unique lettering styles that reveal something about their personalities.

You might try special effects on the word balloons or the lettering to express emotion. A "thank you" written with icicles hanging from the letters is a clever way of indicating that the person is giving the cold shoulder or has no sincerity in what they say.

You can be really creative with words that represent sound effects. The letters you come up with should suit the sound. An explosive *BOOM!* should be written in large, bold text that dominates the panel it appears in; the *HISSSS...* of a slow leak might be written in small, curvy text near the source. Have fun with sound effects, but try to avoid drawing too much attention to every single one. You don't want sound effects to dominate every page and overshadow the art.

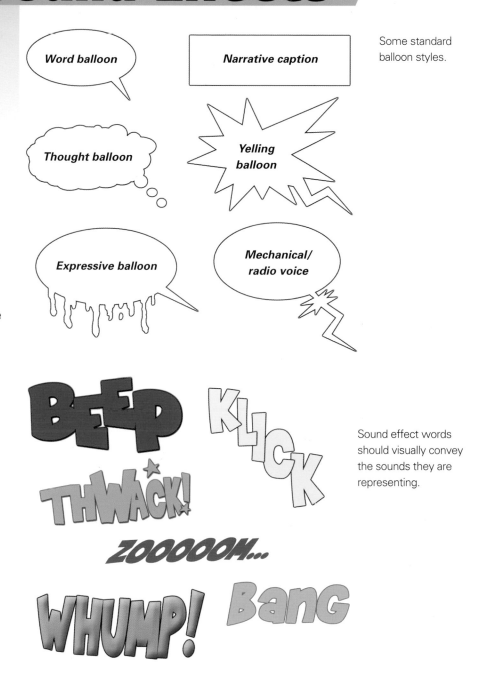

Some standard balloon styles.

Sound effect words should visually convey the sounds they are representing.

Computer-generated fonts such as Comix (shown) are used by most professional letterers. If you are going to letter your comic by hand, make a sample alphabet so that your letters remain consistent.

making a career out of
Creating Comics

Anyone who has drawn comics for fun has been lost in the dream of publishing his own comic and making a living drawing comic books. It's a tricky business to break into, and the competition is intense. If it's fame you want, there are many ways to get your art noticed, but only a few of them pay.

What do you need to do in order to get published? I contacted a few artists and writers in print and Web comics, most notably Todd Nauck (artist on *Young Justice*, *Teen Titans Go!* and his own title *WildGuard*) and Jonathan Morris (Webmaster of Ape-Law.com, an Internet collective of comic artists, and the creator of the Ignatz-nominated web comic *Jeremy*). Their advice and my own experiences with publishing, attending conventions, showing portfolios and working with other comic creators can be summed up as follows.

Meet People and Get Feedback

Meet fellow artists. Build a community of peers that challenge your creative skills and support your work. Put notices up in your school or local comic book store. Post artwork on the Internet for others to critique. Attend comic conventions and visit the artists' alley. Meet the people behind the comics you love. If one of them agrees to review your portfolio, don't panic; this is a great opportunity to show off what you can do.

Portfolio tips:
- *Only show your best and most recent work.*
- *Never apologize about what you have done. Be proud of your work.*
- *Don't show only pin-up drawings. Show comic pages that tell a story.*
- *Show your best three to four pages.*
- *Show your work to as many editors as you can.*
- *Don't argue with the people critiquing your work. Be polite and professional.*
- *Have samples with your name and contact info on each page to leave with editors that show an interest.*
- *Never leave original artwork with anyone. Only hand out copies.*

Shamelessly Self-Promote

Many artists sell small print runs of mini comic books made from folded 8.5" x 11" (22cm x 28cm) paper at conventions or comic book shops. Try to get your minis into shops by giving them an offer they can't refuse. Revenues are usually 40 percent for the seller, 60 percent for the creator. You may want to go 50/50, or just enough to cover your printing costs.

Give your minis to the right people: artists, writers, editors and publishers big and small. Minis are a portfolio designed to show off what you can do. Put your contact information in each comic so people can reach you.

Seek out free website hosts to post your comics on the Internet. Create an online comic and update it regularly. Even if you only post one page a week, in one year you would have a 52-page comic and maybe a loyal following. Comics creator Jonathan Morris found that he probably should have changed his drawing format to suit the computer screen, and he also had to take into account how the reader would navigate through the online work. His most surprising discovery was how unbelievably demanding some fans of his comic were for their free entertainment.

Be Persistent

Look at the credits page of your favorite comic book. Find out who the editor is and address your communications to this person. Editors ignore hundreds of submissions every day because they are busy and can't read everything that is sent in. That's why you have to submit your work all the time. Try sending packages twice a year, then four times a year. They will get to know you and your work. They might even keep some of your work on file. Let them know who you are. Be persistent.

Keep Learning

If you can study art in school, do so. Take courses that will give you a wide range of art experience. These can be courses offered in high school, night classes, colleges or universities. You may even find art lessons offered at your local community center.

Try all kinds of art: sculpture, drawing, painting and computer art. The more education you have, the better. This training can also provide future income in art-related fields like graphic design and illustration.

Have Patience

As important as persistence is patience with every aspect of working in comics. As artist Todd Nauck says, you will need "patience to grow in one's art and skills. Patience with an editor's critique. Patience for that first gig to come through. No one likes to wait, and it takes time for things to break. Be patient."

Credit Where Credit's Due

The following people were integral in the creation or inspiration of some of the characters that appear in this book.

Mitch Krajewski: The Mummy (page 67), Snow Beast (page 67) and Panther (page 78)

Stephen Markan: Kinjaro (page 57)

Caitlin Okum: Gargirl (page 60) and Star Cat (page 55)

Jennifer Okum: Windburn (page 58)

Stephanie Okum: Little Mystery (page 51), Red Ribbon (page 75) and Starlighter (page 54)

Nick Rintche: Blackglove (page 63), Hype (page 71), Shield (page 55) and Tatsu (page 80)

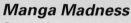